BEAUTIFUL THINGS

Original Art from the Artists of GUILD.com

BEAUTIFUL
THINGS

Original Art from the Artists of GUILD.com

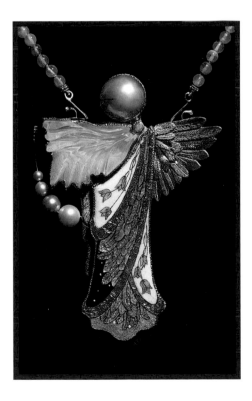

GUILD PUBLISHING

MADISON, WISCONSIN USA

Distributed by North Light Books, Cincinnati, Ohio

FRONT COVER
JEREMY R. CLINE
Birds of Paradise,
tallest 30"H. Blown glass.
Photo by Latchezar Boyadjiev.

BACK COVER
AMY CHENG
Unified Field Theory
(see page 109).

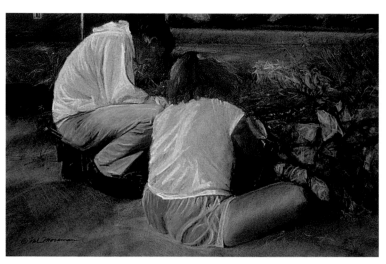

FRONTISPIECE
SUSAN SCULLEY
Pink Punch (detail),
18"H × 25"W.
Oil stick on canvas.
Photo by Cynthia Howe.

TITLE PAGE
MARIANNE HUNTER
River Goddess, 3.75"H × 2.75"W.
24K gold, 14K gold and sterling silver necklace with enamel, pearls and carved Oregon opal.
Photo by George Post.

M.L. MOSEMAN, *Picking Peas,* 1997, 14"H × 21"W. Pastel on paper.
Photo by E. Smith.

Beautiful Things: Original Art from the Artists of GUILD.com

Copyright © 2000 by GUILD Publishing

Contributors: Glenn Adamson, Chris Byrne, Victor Landweber, Michael Monroe and Toni Sikes

CHIEF EDITORIAL OFFICER: Katie Kazan
COVER AND INTERIOR DESIGN: Lindgren/Fuller Design
PRODUCTION ARTIST: Scott Maurer
EDITOR: Nikki Muenchow
ASSISTANT EDITOR: Dawn Barker

00 01 02 03 04 05 06 7 6 5 4 3 2 1

Published by
GUILD Publishing, an imprint of GUILD.com
931 East Main Street
Madison, WI 53703 USA
TEL 608-257-2590 • TEL 877-284-8453 • FAX 608-227-4179
www.guild.com

Distributed to the trade and art markets in North America by North Light Books, an imprint of F&W Publications, Inc.
1507 Dana Avenue
Cincinnati, OH 45207
TEL 800-289-0963

Printed in Hong Kong by C & C Offset Printing Co., Ltd.

ISBN: 1-893164-07-1

CONTENTS

INTRODUCTION

Why Beautiful Things?

TONI SIKES

LET'S BE HONEST HERE; THIS IS NOT AN UNBIASED OPINION. Quite the contrary: I've been passionate about the topic of beautiful things for as long as I can remember.

At first, as I moved from childhood into young adulthood, it was a largely subconscious desire that drew me to galleries, art fairs, the studios of artists. There I discovered the stuff that dreams are made of — beautiful paintings, remarkable sculpture, works in ceramic, glass and other media that resonated with me. This art spoke to me without all the baggage of verbs and nouns, and many pieces seemed to express my heart's deepest yearnings.

By the time I finished college with a degree in mathematics, the subconscious had turned into a conscious decision: I would find a way to work in the arts field. Not that there was really a choice. I had to surround myself with this stuff, and with the talented people who create it.

Over the years, I've struggled to articulate my feelings about art, beauty, beautiful art, and why oh why we need to have these things in our lives. Beauty in art is so complicated and mysterious that it defies explanation, and yet is so simple and straightforward that most recognize it immediately, intuitively. I kept seeking a way to unravel the message, to penetrate the mystery, to interpret the secret of these emotions that stirred my soul.

Being rather persistent (some would say stubborn), I decided that if I couldn't talk and write articulately about the topic, I would just show this work to the world, for all to see. And so, 15 years ago, I started THE GUILD, a publishing company whose books feature the work of leading artists. Our first book, published in 1986, was dedicated to "all those people who adhere to the idea that the world should be filled with beautiful things."

Our website, GUILD.com (www.guild.com), is an outgrowth of THE GUILD. It has been the vehicle for an extraordinary gathering of talent, and it is now the largest online source of original art and fine craft — very beautiful things.

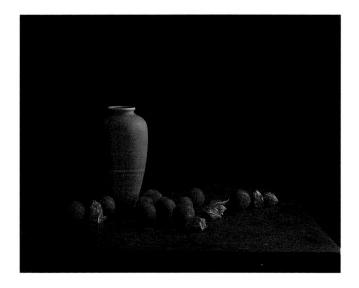

PAUL CARY GOLDBERG, *Les Fruits de Charlevoix.* Iris print.

The job of championing the work of talented artists to the world is an incredibly gratifying one. And yet, as time went by, I realized that what we did at THE GUILD was often at odds with the rest of the art world. Indeed, it seemed that the art establishment was rather disdainful of beautiful work, disinclined to talk about and exhibit the kind of art that makes one exclaim with pleasure.

Why is that? Is it because beauty in art is considered less intellectual, more emotional? Perhaps emotion is too difficult to write about (from a critical perspective) or impossible to judge (from a curatorial perspective).

• • •

The great art critic Roger Fry said, "the word *beauty* I try very hard to avoid." He recognized the difficulty of the subject. The adjective *beautiful*, when applied to art, often carries the connotation of vacuity or superficiality. For instance, a sensuous still-life painting is generally considered by the theorist to be too easy, too accessible, not sufficiently profound.

It is true that the still life does not, for the most part, appeal to the intellect. Instead, it appeals to the spirit. In doing so, it transcends its own ordinariness and becomes something far more profound. A great work of art can give great pleasure; it stimulates our senses and awakens our feelings. Like a story, it draws the viewer in. Critic Wilhelm Worringer referred to it as "a visual resting place."

By refusing to validate the importance of aesthetic pleasure, the contemporary art world has alienated many people who would otherwise be avid supporters of our cause. A simple acknowledgment that we are largely baffled by the power of beautiful art would go a long way toward repairing the damage.

It's time to challenge the preconceptions about what art can and should be. To do this requires nothing less than a groundswell of people who proudly announce that they respect, enjoy and respond to beautiful paintings, sculpture and objects.

We should demand that the National Endowment for the Arts appoint a Minister of Beauty. Let the beauty in art be proclaimed from the ramparts of every city and town in the nation — for all its greatness, and for the way it fills a necessary role in our lives.

Our souls, individually and collectively, need nourishment. Art feeds the soul; it also creates a second world, and that world resembles paradise.

This is art that gives us hope, if for nothing other than a more beautiful world.

Toni Sikes
President
Guild.com

> THIS BOOK IS DEDICATED TO THOSE WHO LOVE
> BEAUTIFUL THINGS AND RESPOND TO THEIR CALL.

JURORS' REMARKS

Sharing Beauty

MICHAEL MONROE

THE ARTWORK SHOWN IN THIS BOOK was gathered and displayed in the 12 months following the debut of the GUILD.com website. It is a small portion of the entire collection of work shown on the site, and a testament to the remarkable vision and talent of the artists at work today.

The artists represented in *Beautiful Things* share a passion for beauty. Their commitment to giving strong visual voice to their ideas expands our appreciation and understanding of beauty — and its ever-elusive essence. The selected works were thoughtfully evaluated by a group of experienced jurors who share the conviction that art should stimulate an interactive exchange. *Beautiful Things* seeks to provide a venue for a richly rewarding conversation between artist, object and viewer.

The strongest and most appealing works of art — in this or any collection — are those in which the artist has made a conscious attempt to pursue inventive solutions rather than repeating proven, trite or contrived formulas. Fueled by a compulsion to take risks, these artists display a rich imagination. As a consequence, their works leave a "record" of the interaction between the maker and his or her art. This record is the tangible evidence of both the artist's touch and his or her thought process, and it prompts the viewer to respond in unanticipated patterns of reacting, evaluating and thinking. These responses bring viewers to a heightened understanding of their world and themselves.

Expecting the artists to raise difficult questions in their work, the other jurors and I were strongly attracted to work suggesting multiple answers rather than a single, obvious one. An immediate and easy understanding of a work signaled the beginning of the end of our interest. Art that invited repeated visits, on the other hand, was highly valued.

Understanding an artist's intention is key to evaluating how successfully he or she articulates the content of the art. The finest artworks manifest a very potent connection

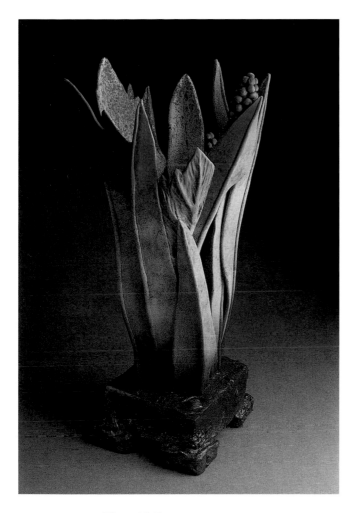

LINDA HUEY, *Blue with Feet*, 1999, 26"H × 11"W × 11"D. Handbuilt ceramic vessel. *Photo by Linda Huey.*

artists who have mastered these skills — not as ends in themselves, but as tools for achieving growth in ideas and content, as expressed in their art.

Although most artists are represented in *Beautiful Things* by a single work, the jurors reviewed several pieces by each artist in an effort to present the strongest example. Considering numerous examples by an artist provided the opportunity for jurors to exercise another important criterion for judging — one of coherence. While some artists prefer to experiment and sample a wide variety of materials, techniques and styles simultaneously, our preference was clearly for artists whose individual bodies of work reflected a singular or closely related theme or idea.

Finally, we believe the strongest artists are those who communicate a highly developed sense of personal expression. Thoughtful and confident, these artists are distinguished by an innovative vocabulary of images and forms.

We are grateful for the generosity of artists who share their images with us and who unfailingly seek to reveal hidden beauty. *Beautiful Things* is testimony to their journey, and we are the richer for it.

MICHAEL W. MONROE
ARTISTIC ADVISOR
GUILD.COM

between the maker's initial idea for a piece — both conceptually and emotionally — and the final expression. The stronger pieces are ones where no "disconnects" exist to suggest a floundering of thoughts. Instead, the works communicate a sense of confidence and verve, an ability to convey idea and emotion with conviction.

The *Beautiful Things* jurors also evaluated the artists' understanding of the inherent possibilities, limitations and appropriateness of materials and techniques. We looked for evidence of how well grounded the artists are in the formal qualities of art: composition, color, design, texture, line, pattern and form. We value those

THE ARTWORK SHOWN IN THIS BOOK WAS SELECTED
BY JURORS MICHAEL MONROE,
CHRIS BYRNE AND VICTOR LANDWEBER.

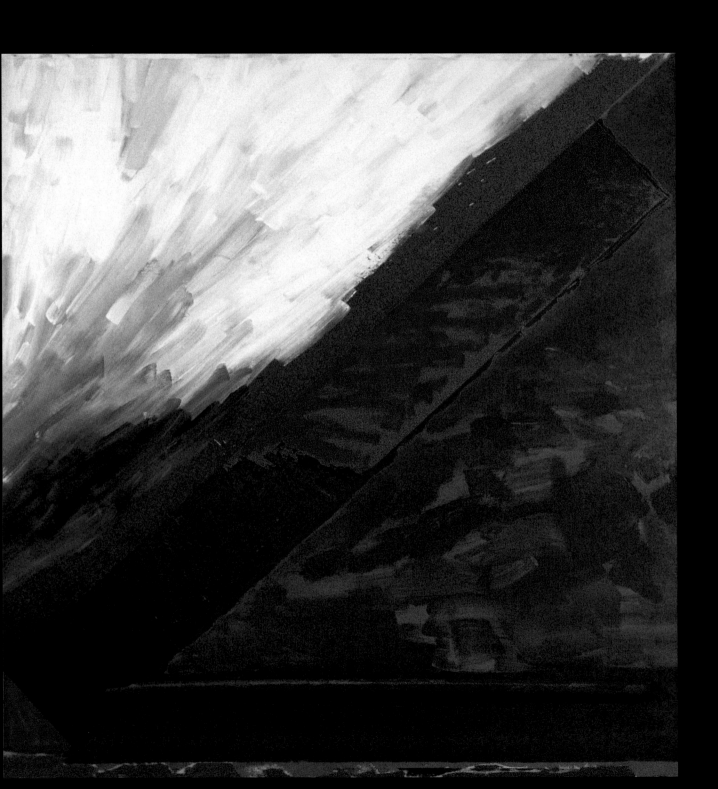

BREAKING THROUGH TO BEAUTY

GLENN ADAMSON

At the moment, authorities on art seem to be in agreement: beauty is "in" again. For the first time in decades, new books on beauty (including this one) are being written. Perhaps in recognition of this trend, the Hirshhorn Museum in Washington, DC, recently devoted an entire exhibition to the subject of aesthetics, entitled "Regarding Beauty." Critics across the nation are wondering why beauty has been away so long; most of them hail its triumphant return.

But before we run to our bookshelves and dust off our old textbooks on aesthetics, the simple question might be asked: did beauty ever really go away? Is it possible that the desire to stimulate that moment of encounter, to achieve that rupture in which we feel transported out of our daily lives and brought to some higher plane, was ever far distant from the intentions of artists?

It seems unlikely. If some talk about a return to beauty today, it is because we are witnessing a moment of change in the definition and perception of beauty itself.

OPPOSITE
WILLIAM MAHAN
Dive, 1978, 87"H × 83"w.
Acrylic and pipe on canvas.

PURISM AND ROMANTICISM

The history of aesthetics can be said to be a pendulum swinging between two opposites: the argument that beauty is objective — that it resides solely in the object; and the counterargument that it is subjective — that the aesthetic experience is something we bring to the object. The father of modern art history, Johann Winckelmann, was one of the first writers to fully articulate the objectivist position. He thought that the highest ideals of art lived beyond history. They were, for him, not subject to the vagaries of taste; they were eternal.

Artists and craftspeople alike took up Winckelmann's ideas as a rallying cry for neoclassicism. Clean lines and ideal geometric shapes held sway over the styles of painting, furniture making and architecture alike. If something was to be curved, it should be curved in a perfect, pleasing composition of two matching parabolas. This was an aesthetics that strove to achieve the certainty of mathematics.

Yet a few decades after his death, romanticism took center stage in the arts and refuted all that Winckelmann had championed. Painters like Géricault and Delacroix swept their brushes passionately across their canvases, more concerned with expressing their own personalities, their own time, than with evoking a high and invariable ideal. The floodgates were open, and within a matter of a few years, the rigid perfectionism of neoclassical design was exchanged for a welter of eclectic decorative styles. Domestic interiors became a compendium of great moments in the history of decoration: Egyptian, Gothic, Renaissance and Rococo.

MODERNISM IN ART AND DESIGN

Today, it seems that we are in the midst of a similar shift toward aesthetic openness — not a rebirth of beauty, but a rethinking of the nature of beauty. For most of the past century, high modernism, which is often blamed for the disappearance of beauty from art, insisted on the most exacting possible interpretation of aesthetics. Following in Winckelmann's footsteps, artists like Mondrian employed what they perceived to be universal and objectively beautiful forms: the primary colors and unwavering horizontal and vertical lines.

Such paintings often gave their audiences few clues as to the whys and wherefores of such austere formalism

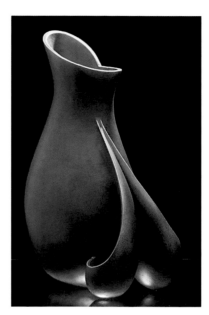

DAVID CALVIN HEAPS, *Water Vessel I.* Johann Winckelmann might have found in the curve of this pitcher a perfect "line of beauty." A blue monochromatic palette accentuates the fluid form and helps the piece evoke the quality of the water it is meant to contain.

— modern artists were, on the whole, not inclined to populism, and they fought against the commonsense notion that beauty is, or should be, easy to grasp. Even today, defenders of beauty are wary of this assumption, and they feel compelled to justify beauty in spite of the fact that it is by nature too simple and too seductive. But modernists valued certain kinds of beauty precisely because they were so difficult to see at first. This is most true not when beauty is hidden behind veils of mannerist style but, ironically, when it is presented in its purest form.

An excellent example can be found in modernist design objects, which for decades tended toward austerity. Decoration was ruthlessly stamped out, and one would think that the creators of tubular steel chairs and plain white dishware were entirely uninterested in aesthetics. But nothing could be further from the truth. The logic of these designers was that an object should be beautiful in all times and all places, and to all people. This could only be achieved if everything extraneous were removed from the design. The objective considerations of function and material were to be the sole determinant of the form. And indeed, the pundits of modern design reacted harshly

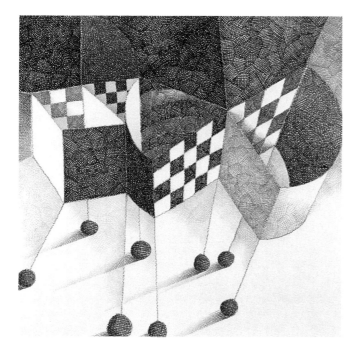

ROSS VAN DUSEN, *208*. Here a contemporary painter offers a whimsical reinvention of geometric paintings by the likes of Piet Mondrian, finding a way to insert a human touch into the restrained visual language of primary colors, lines, squares and triangles.

even to tentative forays into extraneous ornament. In 1950, for instance, curator Edgar Kaufmann at the Museum of Modern Art wondered why on earth a toaster should be enlivened with streamlined curves if it were not meant to do any high-speed traveling. An appliance should express its useful purpose, he argued, and that was that.

BEAUTY TODAY

The purist attitude toward art and design is still around. As long as there is restraint in art, or geometric precision, or color that floats freely before the eyes, those who side with Winckelmann will have something to look at. But of course when people talk of the return of beauty, this purism is precisely what they do not mean. They are talking about the renewal of a "vernacular" type of beauty, beauty that everyone really can experience, not only in theory but also in practice.

This idea of beauty gives more credit to those who look at the art. The dictates of an abstract and supposedly universal concept are overthrown, as the viewer becomes the arbiter of what is and is not beautiful. The notion that art should puzzle the uninitiated is, after all, an elitist idea. Showing both the justifiable pride and the lamentable intolerance of modernism, Picasso once said, "the fact that for a long time cubism has not been understood means nothing. I do not read English; an English book is a blank book to me. This does not mean that the English language does not exist, and why should I blame anyone else but myself if I cannot understand what I know nothing about?"

In response it may well be asked, "why should we have to struggle to learn how to appreciate art, when it could reach out to us in an uncontrived attempt to please?" More and more artists, it seems, are asking this question of themselves; and as a result, perhaps there is a shift away from purism in art today. But again, it is debatable how widespread the phenomenon of "difficult beauty" ever was. It's true that the puritanical abstract expressionist painter Barnett Newman claimed that "the impulse of modern art is the desire to destroy beauty." But hasn't that opinion always been very much in the minority? In fact, the notion that beauty went away on a long hiatus is only credible if one looks at the thinnest possible definition of art, only the paintings and sculpture of the European and American avant-garde tradition.

DECORATION AND CRAFTSMANSHIP

If we go to the edges of the modernist tradition or, for that matter, outside of it entirely, a completely different definition of beauty awaits us. Here, the object's primacy is balanced by an understanding of the viewer's role in the

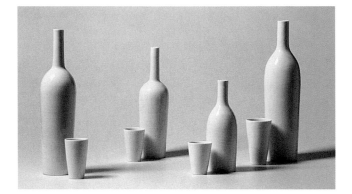

GILDA WESTERMANN, *Still Life.* If modernism is about coming to grips with the most essential qualities of form, then Gilda Westermann is certainly a modernist. She zeroes in on the theme of relative scale, one of the most important inherent characteristics for a functional object.

relationship. Decoration floods in again. Toasters, teapots and paintings alike are lavished with whimsical compositions or visual languages drawn from specific cultural traditions. It is not surprising that decoration is a signifier of cultural vibrancy, almost a code for artistic populism. From the feminist "pattern painting" of the 1970s to art inspired by the traditions of South America, Africa and Asia, decoration is everywhere. As museums become ever more aware of the ethnically diverse communities around them, it becomes more and more clear that decoration never left art; it was just hidden from view by the dominant voice of modernism.

The same can be said for another eternal wellspring of beauty: fine craftsmanship. For a long time, it was mistakenly thought that craft had been slain by the machine, or that mass production spelled the end of quality. With the benefit of hindsight, it is clear that craft has grown to be a vibrant counterpart to advanced industry. A finely made object offers satisfactions that can be gotten no other way. What's more, craftspeople have grown to adopt the machine as their own, turning power woodworking tools and even computers to the ends of aesthetic accomplishment. The confluence of craftmanship and technology continues to be an area in which the creative impulse finds root and generates endless formal experiments.

Nonetheless, we can say that craft is conservative, in the best sense of that word. As inventive as they are, craftspeople spend much of their time preserving or reviving old skills, whether they deal with wood or clay, or even paint on canvas — for many of today's painters are truly craft artists. Like the purism of modernity, or the traditionalism of decorative styles, craft is deeply linked to the past. And perhaps this is what all of the aspects of 20th-century beauty have in common — a desire to hold on to that which is worthwhile in culture.

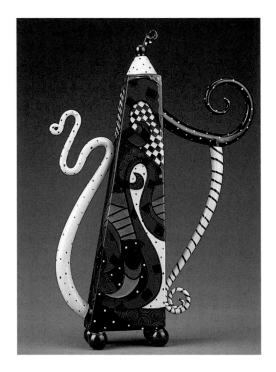

STEVEN MCGOVNEY & TAMMY CAMAROT *Tower Design Teapot.* This elaborate teapot would have been a nightmare for Winckelmann, but today it is most enjoyable as a celebration of the interaction of sculpture with pattern. Husband and wife team McGovney and Camarot prove that decoration is among the most expressive and complex of artistic tools.

PETER PIEROBON *Jargon Dresser.* Peter Pierobon combines a keen sense of both historical furniture and contemporary style in this dresser. The overall design is that of a traditional chest of drawers. But the expertly carved, looping letters that embellish the façade point to the notion that decoration is a language of communication.

BREAKING BARRIERS

Maybe that is why beauty has a reputation for having gone away, why we may feel like it has to be constantly resuscitated. Particularly in the arts, a desire to forge boldly ahead into the future seems ever at odds with the fear that progress will land us in an unfamiliar, inhuman territory. In this struggle, beauty (in the sense that it is identified with the classic styles of the past) often seems to be the loser, as new and challenging forms sweep in to amaze and shock the public.

Still, when we look at the products of yesterday's aesthetic contests, we invariably find beauty. We see this in personal struggles like those of Van Gogh or Cézanne. And it is no less the case with public struggles over art, from Impressionism, which was first reviled as being incomprehensibly abstract, to the once-controversial graffiti paintings of the 1980s, which now seem so stylishly attractive. By looking at the question of aesthetics this way, we can begin to see beauty the same way that makers do: as the thing that happens when a barrier has been broken.

When looking at this book of newly made "beautiful things," I am struck again and again by the question: is this object actually beautiful? Often the answer is "yes"; sometimes, perhaps when a thing is especially powerful, it is less easy to know. When I am unsure, however, I try to remind myself that every artwork is an occasion for a relationship to develop between a maker and a user, a creator and a consumer. I know that this relationship is, at

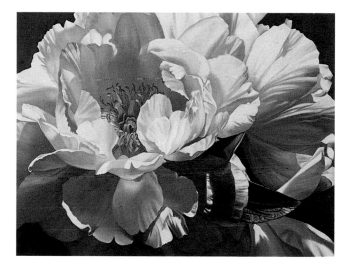

BARBARA BUER, *One White Peony.* The tradition of flower painting extends back through Impressionists and Dutch still-life artists, but in her use of dramatic close-up, Buer is most indebted to the example of Georgia O'Keeffe. Still, the hallucinatory super-realist style of her flowers is unique and attests to the fineness of her craftsmanship.

some level, only a feeling. Others might feel differently than I. But that is simply the subjective nature of beauty. The aesthetic experience may not be tied to universal and endless visual qualities, but the experience itself — the sensation of falling in love with an object — is timeless. And it really is a beautiful thing.

CONCEPTS OF CONSTRUCTION

FOR AN ARTIST OR CRAFTSPERSON, there is nothing that affords more interest and delight than the act of making itself. Normally, this process is hidden from the viewer — the greatest challenge of craftsmanship often consists in hiding its own traces — but this does not have to be the case. By clearly articulating the ways that a work is constructed, an artist can instill it with a very particular kind of aesthetic, with its own history and set of associations. The style of the arts and crafts furniture made at the beginning of the 20th century, for example, was premised on the honest disclosure of its own construction. Beginning with the invention of perspective, painters have used the geometric imagery of architecture as a way of similarly unveiling the structure underlying their compositional arrangement. Rather than offering technical bravura, such candid artworks offer the viewer a glimpse into the work habits and formal choices of the maker.

OPPOSITE
CAROLINE JASPER
Sunbaked Shadows, © 1999, 24"H × 18"W.
Oil on canvas.
Photo by Daniel Whipps, Baltimore.

Time and Place 27, 1997, 18"H × 18"W. Oil on canvas.

Rainy Day in Maine, 26"H × 25"W. Handpainted film collage with pastel.

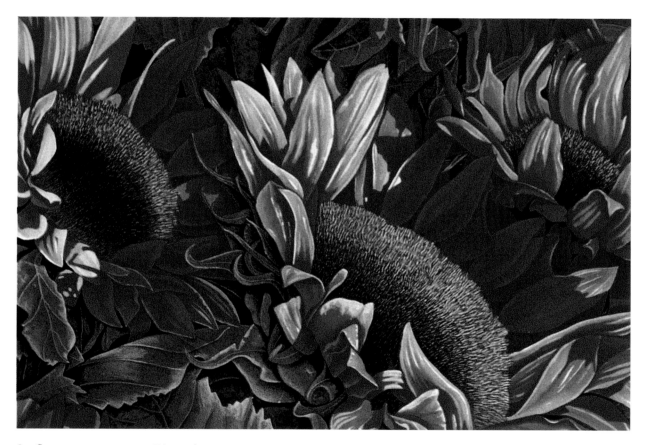

Sunflowers, 29.5"H × 41"w. Watercolor on rag paper.

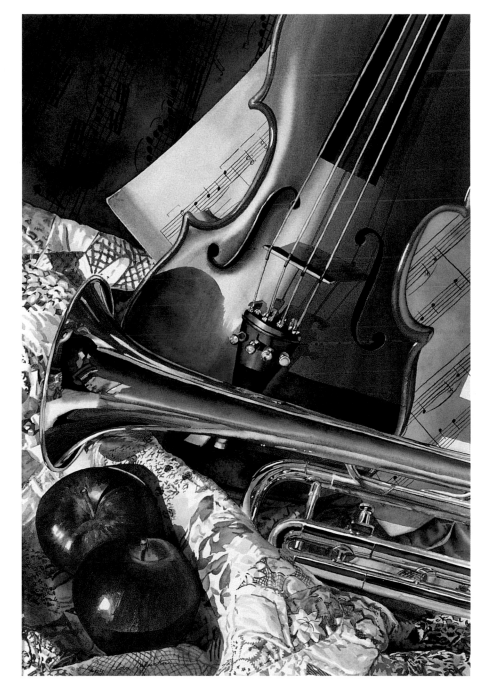

My Dad's Violin, 1998, 26"H × 40"W. Watercolor on paper.

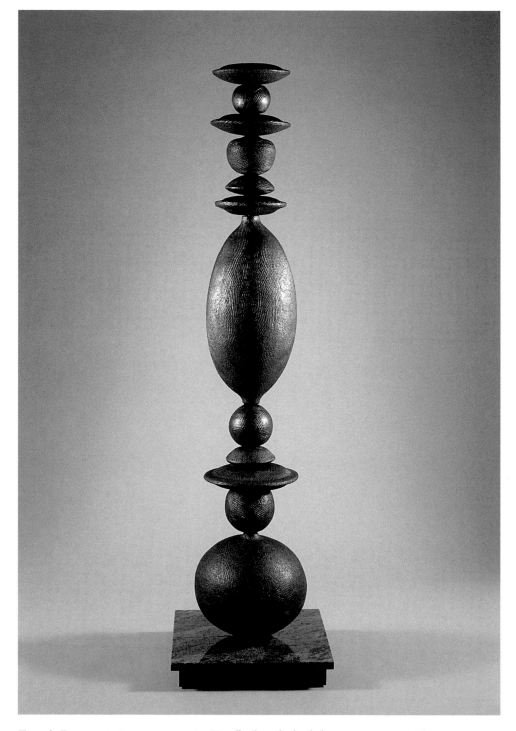

Totemic Dreams, 64"H × 13"W × 13"D. Handbuilt and wheel-thrown stoneware with manganese dioxide wash. Part of the *Totemic Dreams* series. *Photo by Courtney Frisse.*

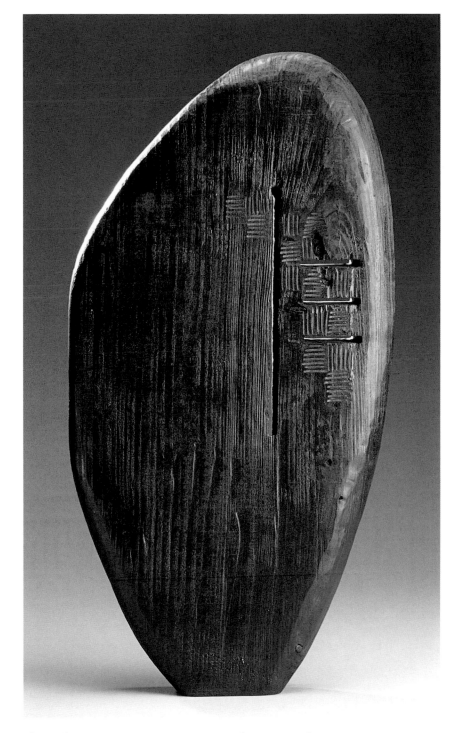

Slip Rock, 1999, 24"H × 12"W × 2"D. Burned cypress wood. *Photo by Matt Bradley.*

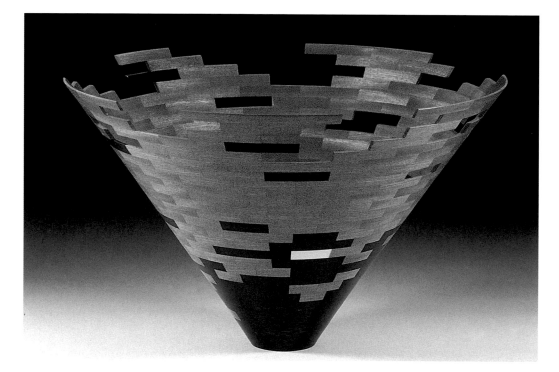

Prairie Amarillo, 1998, 9"H × 14"DIA. Brazilian satinwood, African ebony and avonite. Part of the *Carved Conics* series. *Photo by Bud Latven.*

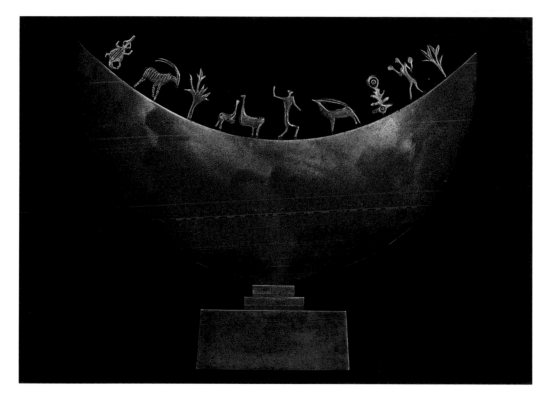

Moon Sculpture, 18"H × 23"W × 5"D. Bronze.

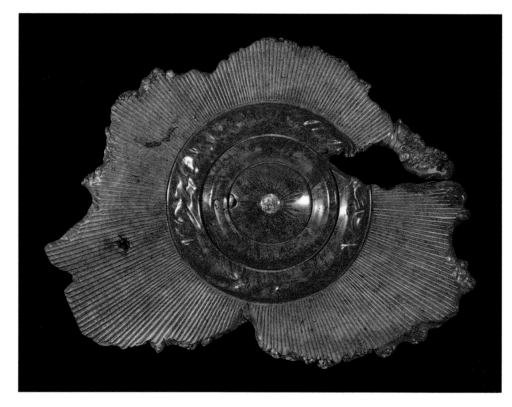

Fiesta, 24.5"ʜ × 32"ᴡ × 2"ᴅ. Big leaf maple burl and agate.

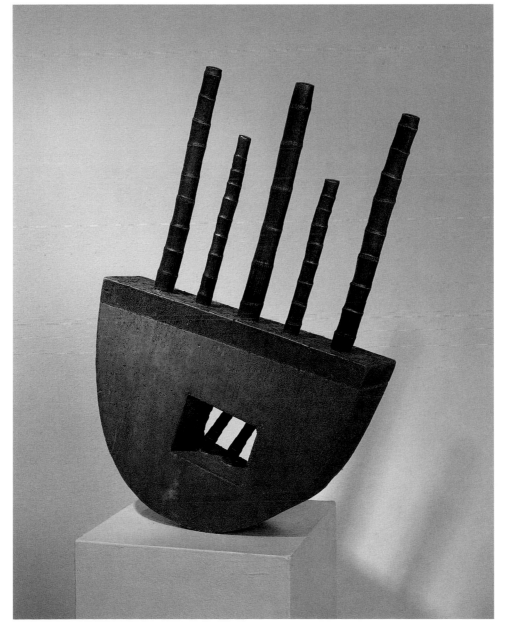

Areca Wand, 1999, 42"H × 24"W × 6"D. Dyed concrete and bronze. *Photo by Guadalupe Fine Art.*

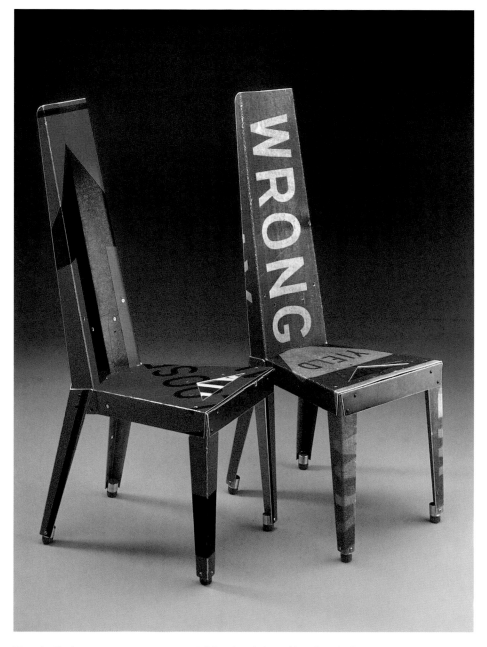

Transit Chairs, 48"H × 16"W × 21"D. Soldered and riveted hand-picked street signs.
Photo by Dean Powell.

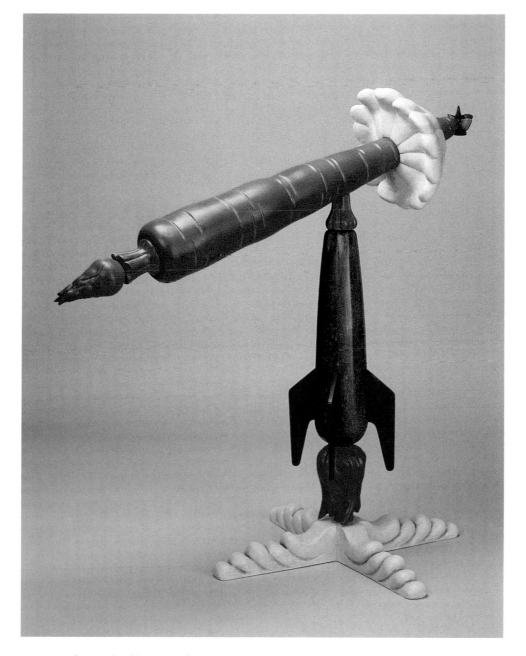

Unmanned Interplan(t)etary Probe, 1989, 25"ʜ × 27"ᴡ × 15"ᴅ. Oil-painted wood. From the *Flying Vegetable* series.

Emerging Blue, 24"H × 30"W (mounted). Painted silver print.

Toronto Arches. Silver gelatin print.

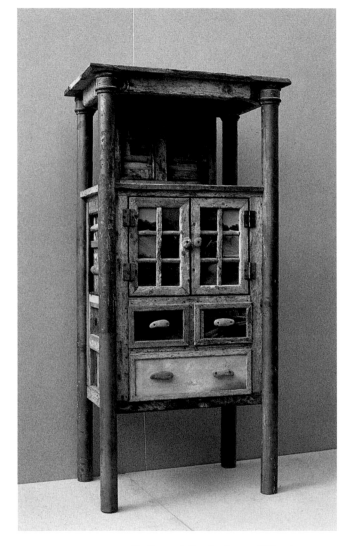

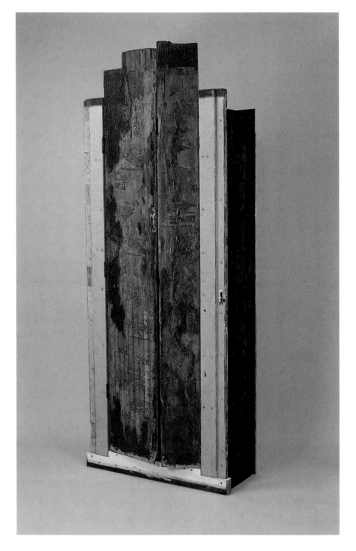

ANDREW HOLMES, *Driftwood, Drainpipe and Fine Art Cabinet,* 60"H × 30"W × 20"D. Iron, driftwood and genuine 19th-century oil paintings.

STEPHEN WHITTLESEY, *Coverings,* 93"H × 37"W × 16"D. Salvaged 150-year-old wood with antique wallpaper.

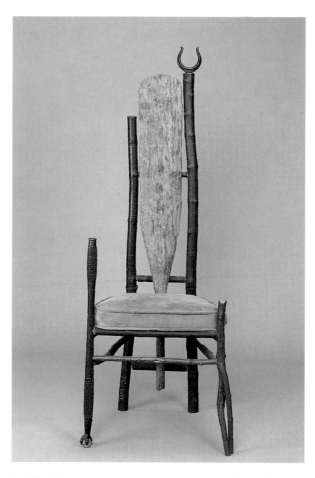

Paddle Chair, 1992, 51"H × 22"W × 23"D. Saplings, found objects and suede. *Photo by Ron Cedar.*

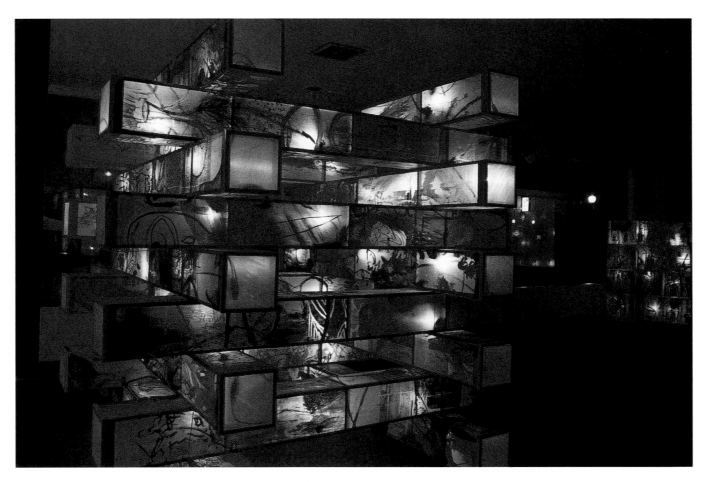

Crystal, 9'H × 8'W × 8'D. Aluminum, polycarbonate and silk.

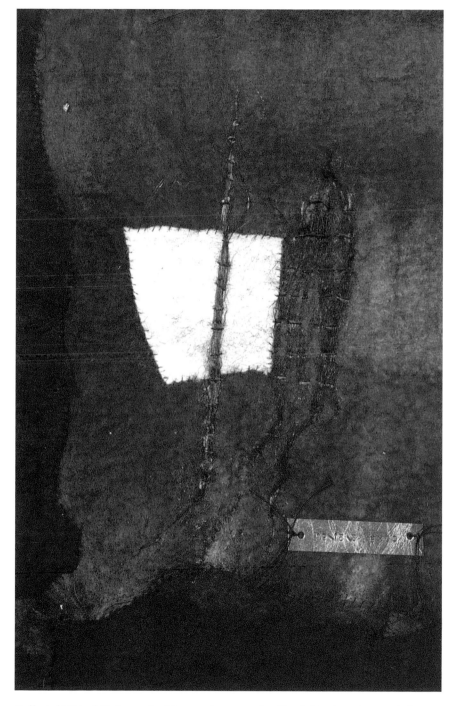

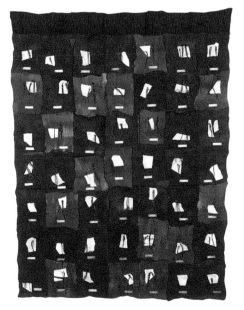

Collected Ethical Verbs, 1996, 61"H × 52"W × 0.25"D. Hand-felted merino wool, fleece, beeswax, copper plates and thread. *Photos by Walker Montgomery.*

Fountain sculpture and partition wall, sculpture: 20'H, wall: 42'L. Glass. *Photo by Joaquin Pedrero.*

Sea of Time, 1999, 23'H × 100'W × 6'D. Part of an installation of three component sculptures, *Chronos Trilogy*. Photo by Gerry Kopelow.

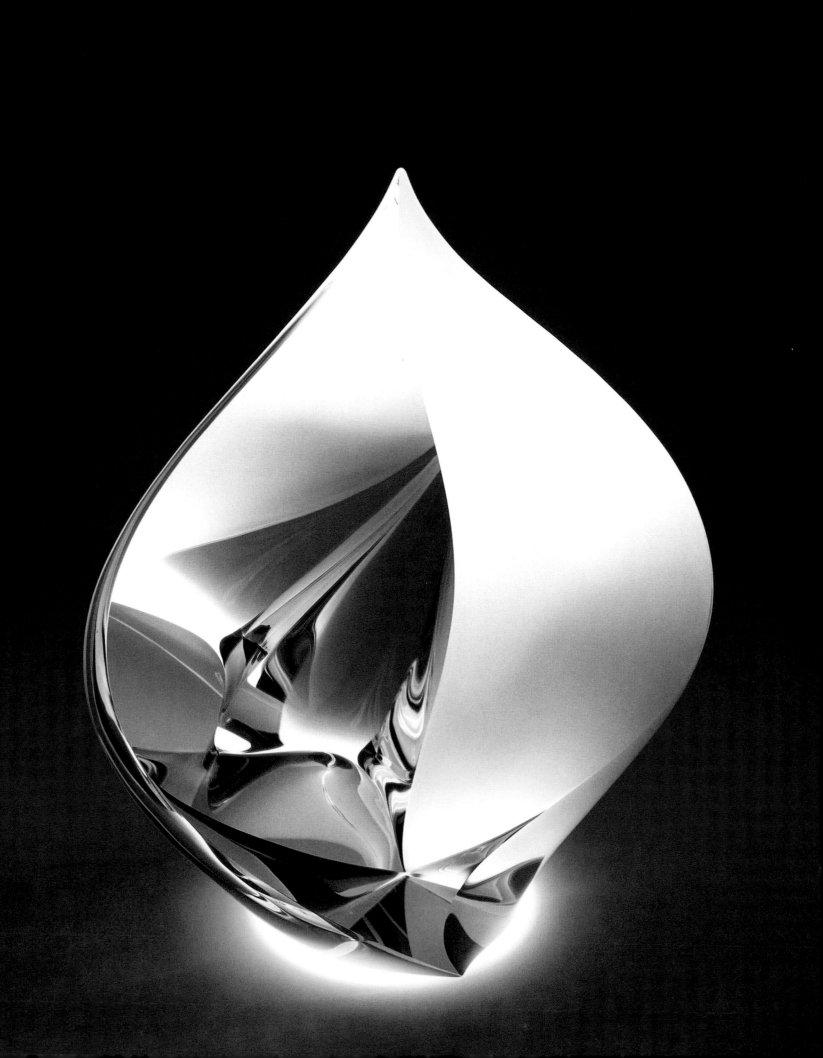

THE SENSUOUS FORM

ONE MARK OF A GREAT CRAFTSPERSON, whether a painter, a woodcarver or a potter, is the ability to breathe life into inert matter. It is no mean feat to fashion the pneumatic pressure that seems to expand within a sculptural form, or the tautness of a line that hugs a field of painted color. This is the area of craft in which the maker's body is most directly inscribed, and for this reason sensuous form always bears with it a very personal imprint. Indeed, the way an artist draws the contours of a body or shapes the curves of a piece of pottery is as individual as a fingerprint. Maybe this is why we are so prone to touch sensuous things — they are as close as art comes to the actual act of touching another person.

OPPOSITE
CHRISTOPHER RIES
Afterglow, 9.25"H × 6.25"W.
Optical glass.
Courtesy of Holsten Galleries.

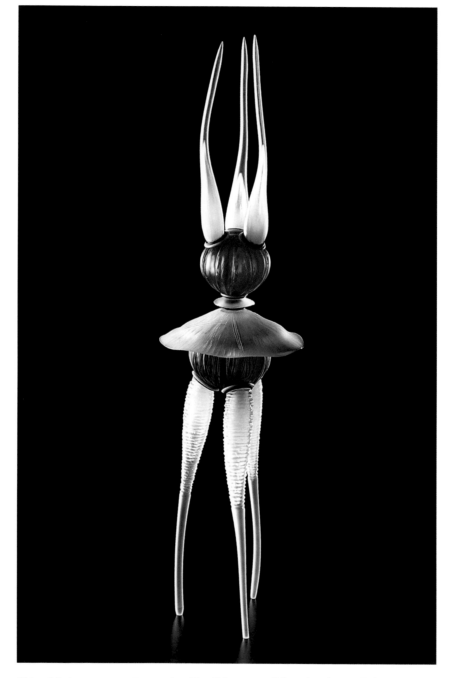

Skirted Spires, 1999, 34"H × 10"W. Handblown, sandblasted and carved glass.
Photo by Don Pitlik.

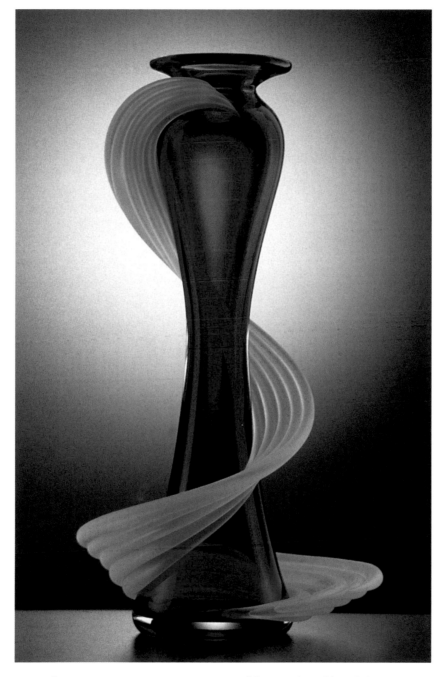

Large Flamenco Vase, 13"H × 6"W × 6"D. Handblown and sandblasted glass.
Photo by Frank Borkowski.

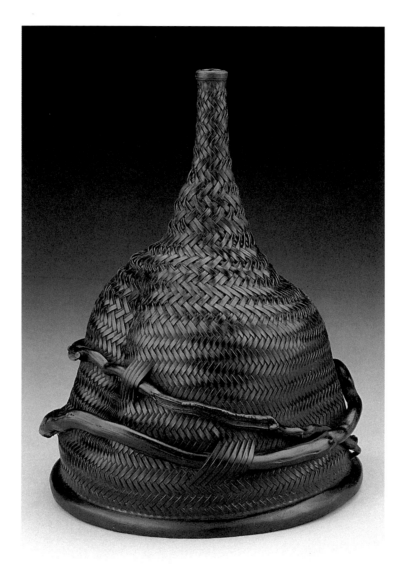

Crane, 1999, 10"H × 8"DIA. Basket of bamboo, cane, cedar root, wood and urushi lacquer. Courtesy of Katie Gingrass Gallery.

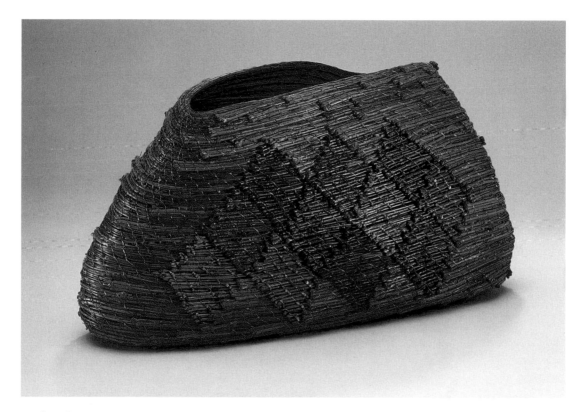

Patchwork, 1999, 8"H × 14.5"W × 4.5"D. Long-leaf pine needles, brass wire, glass seed beads and beeswax. Courtesy of Katie Gingrass Gallery.

From the *Human Forms 1965–1966* series, 1996, 11"H × 14"W. Silver gelatin prints.

Photos by Barbara Crane.

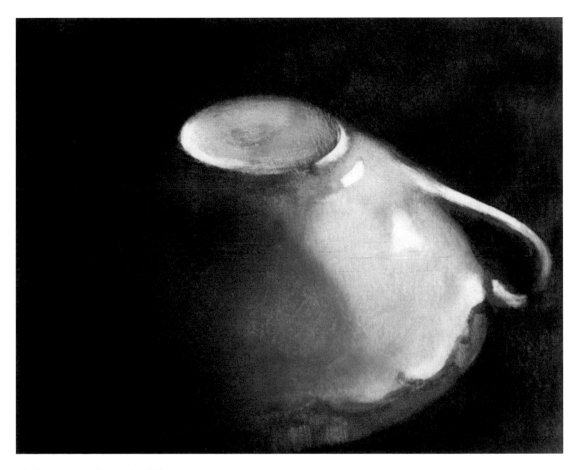

Half, 1995, 4.75"ʜ × 5"ᴡ. Oil on paper.

Untitled (blue), 2000, 14"H × 11"w. Cibachrome print. Courtesy of TATE. *Photo by TATE.*

Untitled (yellow), 2000, 14"H × 11"w. Cibachrome print. Courtesy of TATE. *Photo by TATE.*

Talk Talk, 22"H × 30"W. Collage and acrylic. *Photo by John Ferrentino.*

Birds Over the Lake, 31"H × 48"w. Oil paint on canvas. *Photo by Charles Munch.*

Four Seasons, 26"H × 46"W × 1"D. Wall piece with earthenware clay, applied details and colored porcelain slip decoration. *Photo by Tim Ballingham.*

ELLEN MEARS KENNEDY
Harlequin: Diamond Brights,
54"H × 43"W × 4"D.
Handmade abaca paper.
Photo by Joel Breger.

SUSAN DUNSHEE, *Silva* (detail), 48"H × 60"W × 3"D. Cotton-rayon yarn, nylon netting and fabric.
Photo by Susan Dunshee.

Eclectic Contraire (detail), 1998, 12"H × 12"W × 1"D. Fiber wall piece of mixed media, stretched devoré and leno fabrics.

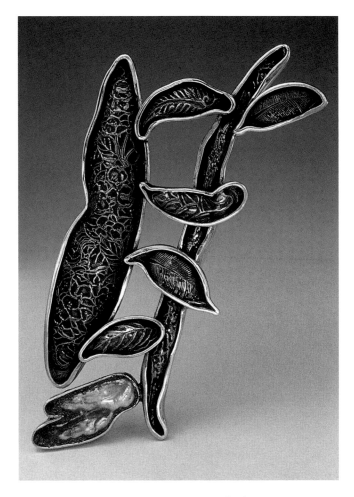

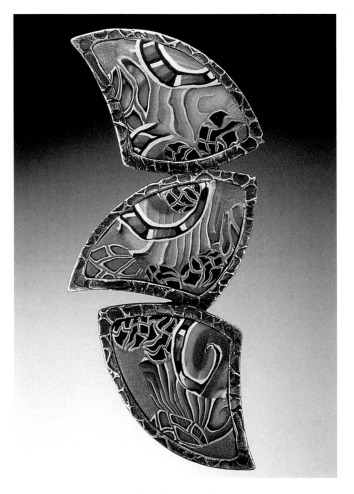

SUSAN SILVER BROWN, *Down Deep in the Hope,* 1999, 5.5"H × 1.75"W. Sterling silver, copper, gold foil, brass and mother-of-pearl brooch/pendant. *Photo by Jeff Scovil.*

SHELLIE BROOKS, *Three Tier Brooch,* 2.4"H × 1.6"W × 2"D. Sterling silver with inlaid polymer-based clay collage. Part of the *Chidori* series. *Photo by Ralph Gabriner.*

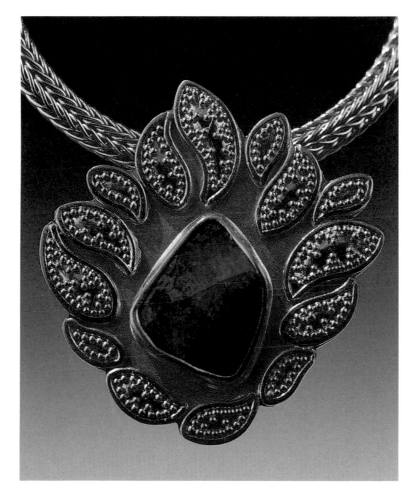

Peacock, 1.17"ʜ × 1"ᴡ × .25"ᴅ. Australian boulder opal set in 22ᴋ gold pin/pendant. *Photo by Jerry Anthony.*

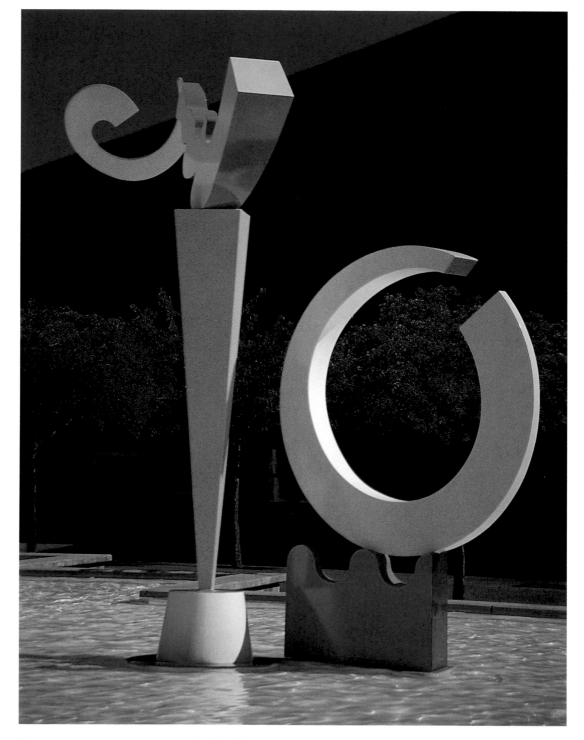

Sweep, 1999, 15.5'ʜ × 13.5'ᴡ × 6'ᴅ. Steel and concrete. *Photo by Roy R. Crockett.*

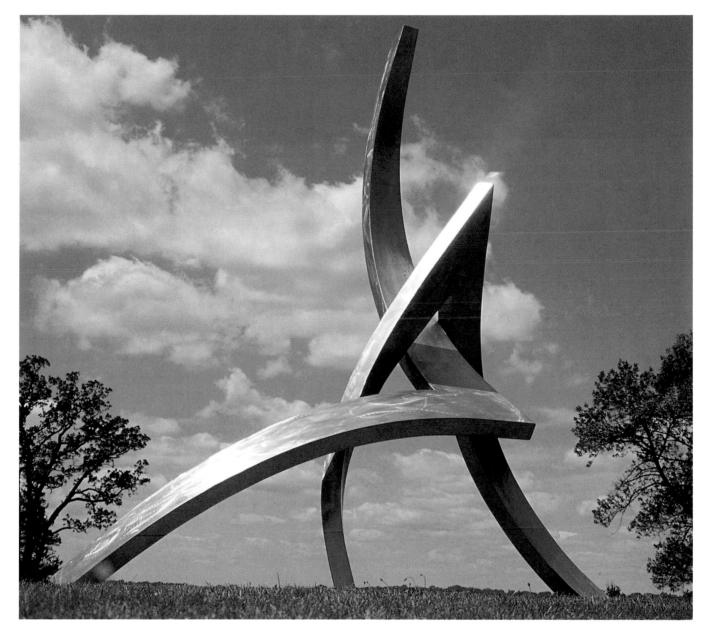

Two Can Dream, 1995, 8'H × 9'W × 5'D. Stainless steel.

Metamorphosis, 13.5"H × 27"DIA.
Lacquered buckeye burl.

Photo by Ron Fleming.

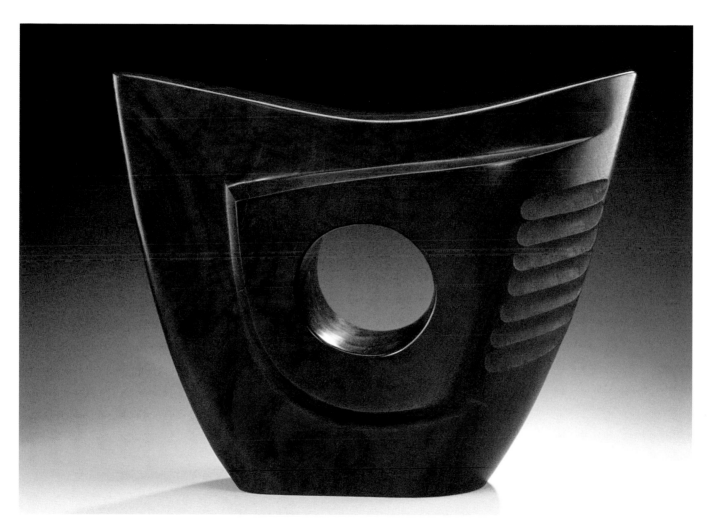

Muse (3-01), 1999, 20.5"H × 26"W × 6.5"D. Black walnut.

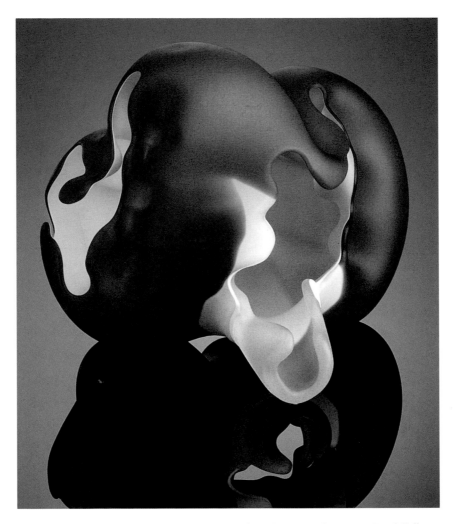

IGS III Series, 1988–93, 17"ʜ × 22"ᴡ × 22"ᴅ. Glass. Courtesy of R. Duane Reed Gallery.

Red: Act III, 1997, 16.75"H × 22.75"W. Acrylic inks on paper. *Photo by Hedi Desuyo.*

GWENN CONNOLLY, *Joy,* 35"H × 12"W × 7"D. Metal.
Photo by Bill Shank.

LEONARD A. URSO, *Woman,* 1998, 78"H × 12"W × 12"D.
Hand-formed and raised 8-gauge copper. Courtesy of Sitta Fine Art.
Photo by Dean Powell.

Essence, 1995, 31.5"H × 11.5"w. Lost-wax cast bronze handpainted in polychrome.

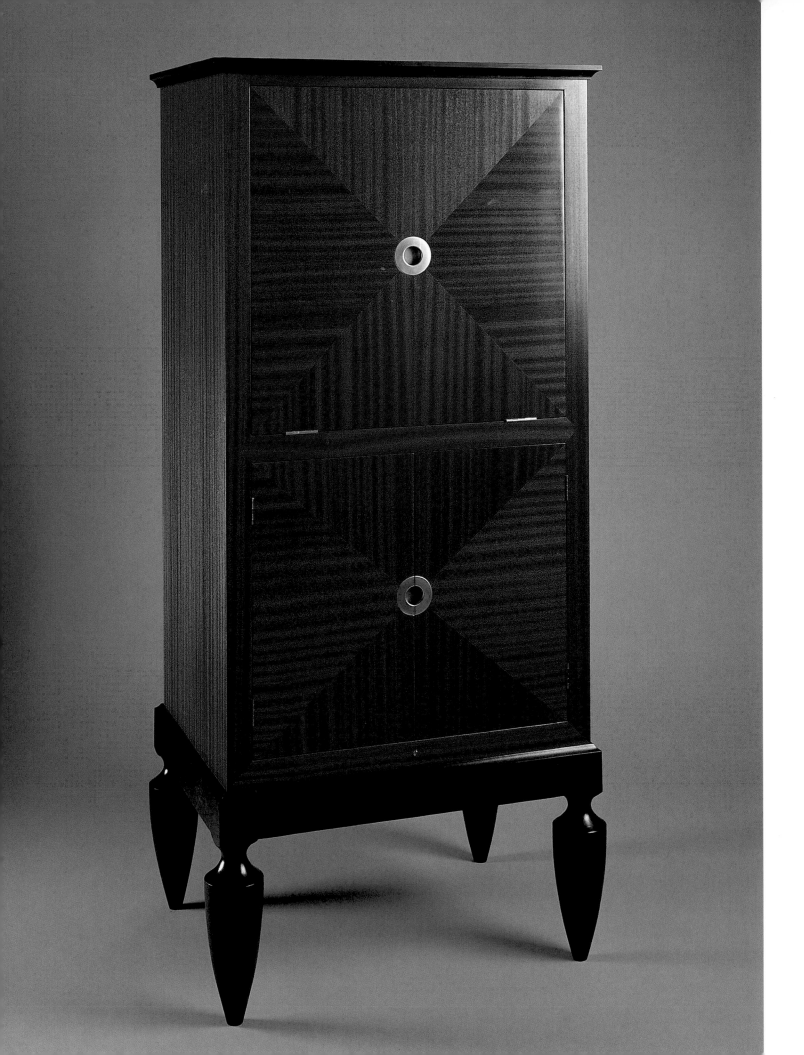

THE PLEASURE
OF FUNCTION

For DECADES, FUNCTIONALITY has been the most hotly contested term in the crafts. Must a thing serve a purpose to truly be a craft? Are the standards of craftsmanship always to be judged on the basis of the pleasures of use, rather than the pleasures of vision? Such questions quickly lead down the slippery slope of semantics. Fortunately, the debate makes little difference when the hand takes up a truly well-made thing and puts it to doing what it does best, whether that be pouring, cutting or simply containing. Only in use does the relation of the maker's body to the user's body achieve its point of closest contact. Only through use does one feel the subtlest nuance of an object's form, if only subconsciously. Even if function is not an indispensable part of craft, it is unquestionably craftsmanship's lifeblood.

OPPOSITE
DON GREEN
Media Cabinet, 72"H × 29.75"W × 23"D.
Sapele, ebonized mahogany and nickel
hardware. *Photo by Drew Harty, 2000.*

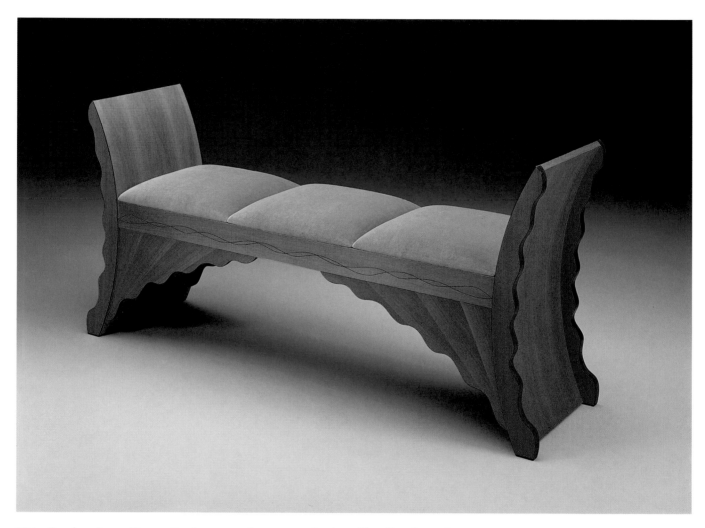

Water Bench, 27"H × 58"W × 16"D. Lemonwood veneer on a laminated bending plywood core. *Photo by Dean Powell.*

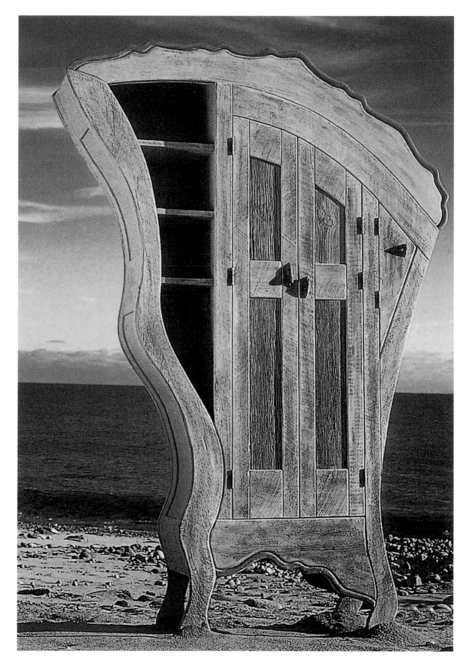

Neptune's Armoire, 84"H × 59"W × 14.5"D. 140-year-old barn wood and hardwoods painted with Latex housepaint. *Photo by Steve Rodgers.*

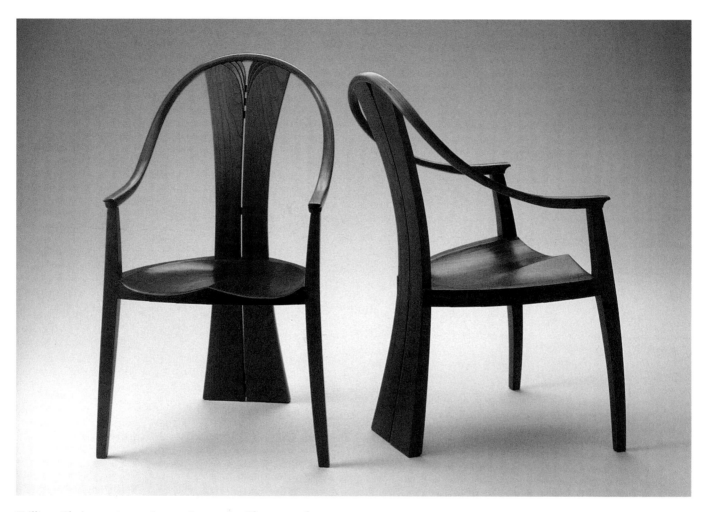

Trillium Chairs, 1996, 37.75"H × 22"W × 21"D. Cherry wood. *Photo by Thomas Ames.*

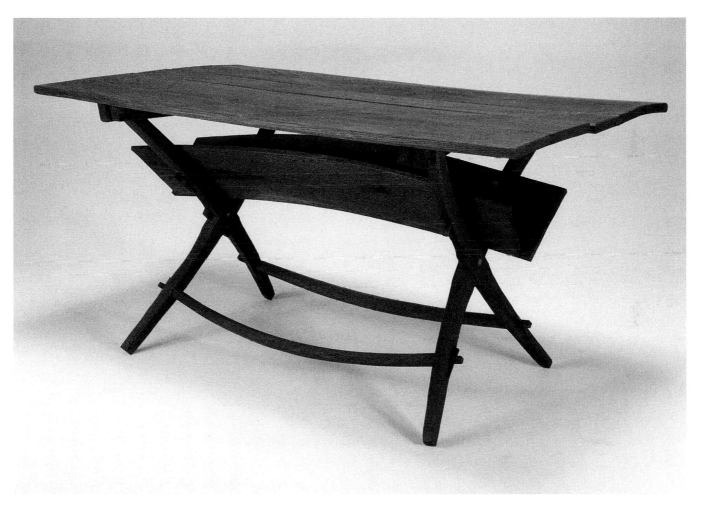

Trough Table, 1999, 32"H × 32"W × 60"D. White oak. *Photo by Courtney Fair.*

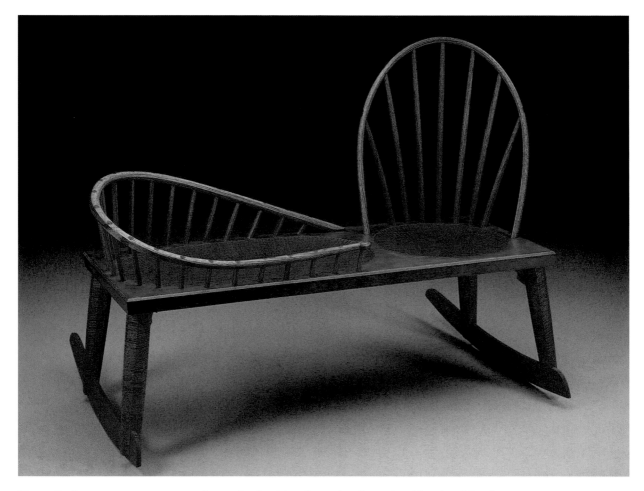

Nanny Rocker, 39"H × 49"W × 32"D. Steamed oak, white pine and curly maple with painted details. *Photo by Dean Powell.*

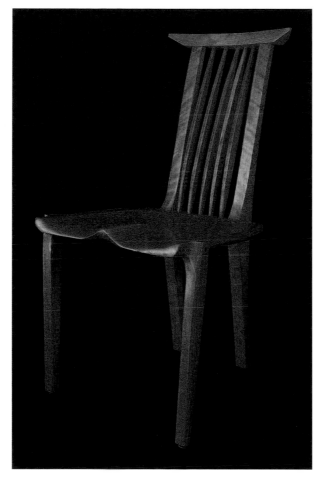

The Skinny Lady, 38"H × 20"W × 23"D. Cherry wood.
Photo by R.A. Laufer.

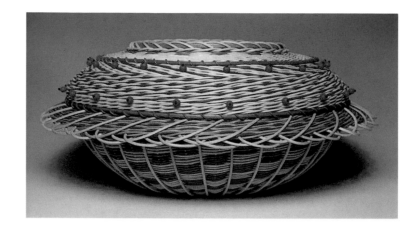

SALLY METCALF, *Mother Ship*, 1999, 7.5"H × 16"DIA. Naturally dyed rattan reed with wooden beads. *Photo by Sally Metcalf.*

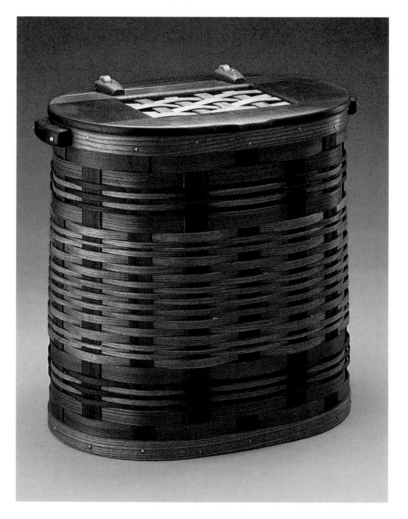

KEITH RAIVO & VALERIE RAIVO, *Small Hamper*, 18"H × 17"W × 12"D. Red elm with walnut. *Photo by Wayne Torborg.*

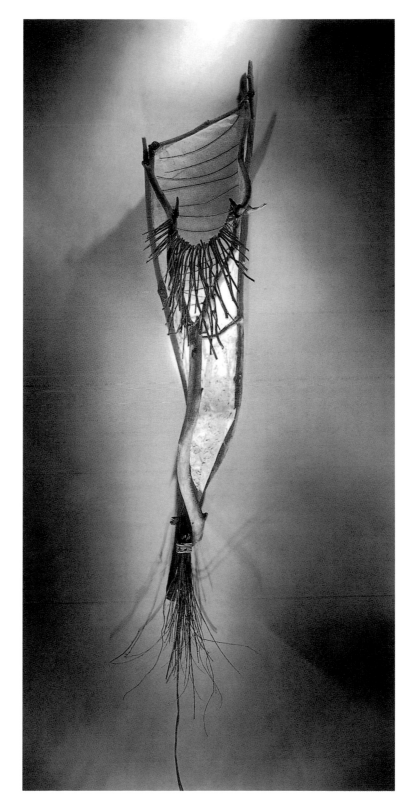

Sconce, 1998, 60"H × 15"W × 11"D. Mixed media. *Photo by Paul Dingman.*

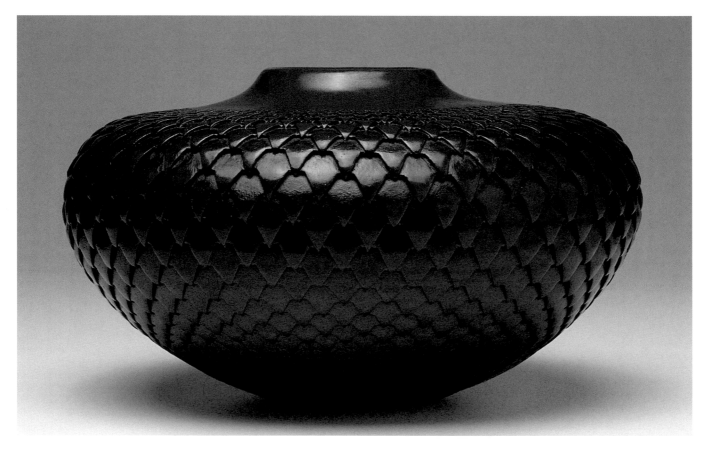

Squash Vessel, 7.5"H × 13"DIA.
Cast bronze.

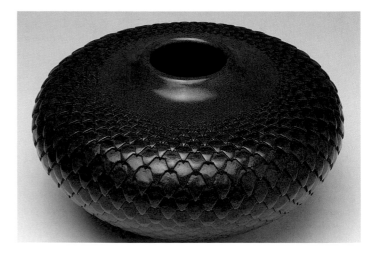

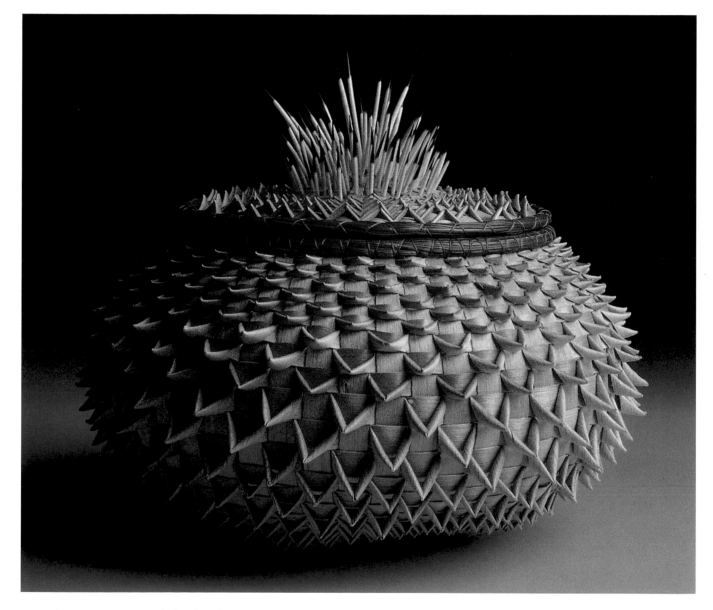

Porcupine, 11"H × 11"DIA. Black ash with pine needles and porcupine quills. *Photo by Jeff Baird.*

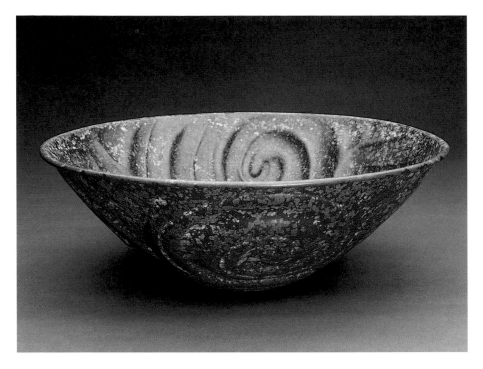

J. AGNES CHWAE, *Codex Mendoza,* 1994, 8"H × 13"DIA. Copper with sawdust patina.
Photo by Jim Wildeman.

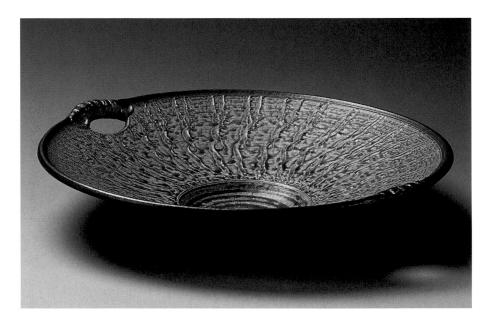

THOMAS CLARKSON, *Ceramic Bowl,* 14"DIA. Wheel-thrown ceramic with wood-ash
glaze. *Photo by Hubert Gentry.*

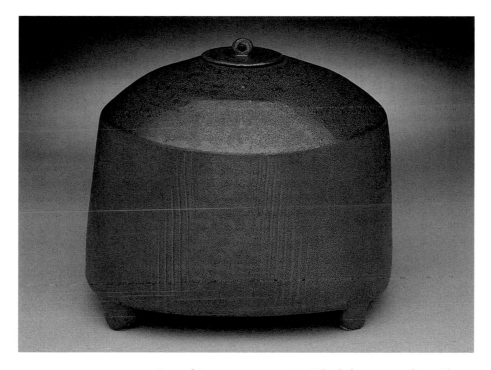

KATHLEEN NARTUHI, *Covered Jar,* 6"H × 8"W × 7"D. Wheel-thrown porcelain with metallic glaze. *Photo by George Post.*

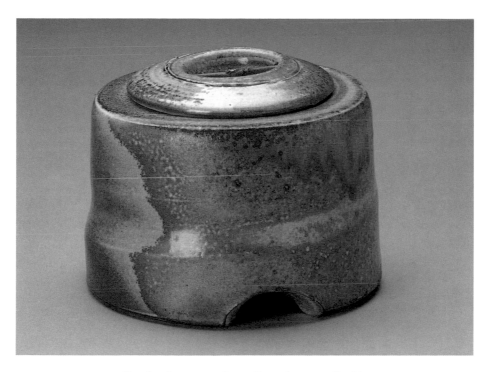

BYRON TEMPLE, *Bamboo Jar,* 1999, 4"H × 5"DIA. Anagama-fired jar. *Photo by Andy Rosenthal.*

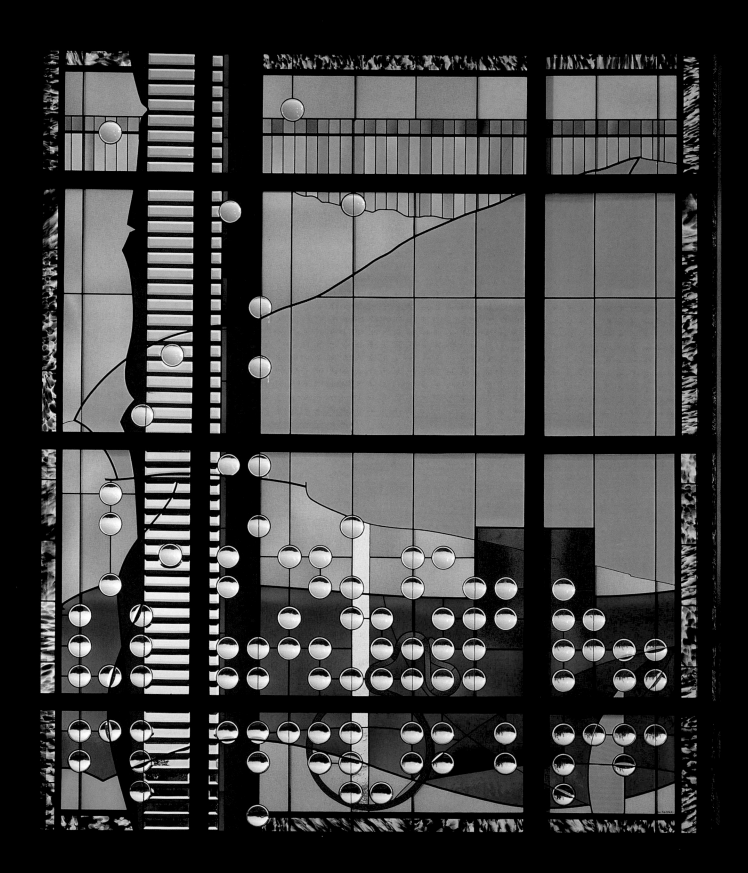

PATTERN
AND GEOMETRY

PATTERN AND GEOMETRY ARE STRANGE BUT CONSTANT BEDFELLOWS. They seem, at times, to be the same thing: what is a pattern, after all, but a repetition of squares or triangles? Yet in a sense, the two are opposites. Patterns are made by the human mind. As the art historian E.H. Gombrich has written, they are the means by which we impose a "sense of order" on the world around us. The geometric, on the other hand, is that category of form that lies most outside, or perhaps beyond, the human imagination. The perfect circle, the exact square cannot be held in the hand, but they are standards against which we judge everything in our experience. In this respect, our impulse to organize geometry into decorative pattern must be considered the most primal of our creative instincts.

OPPOSITE
GUY KEMPER
13.5'H × 10'W.
Blown beveled and cast glass.
Photo by Walt Roycraft.

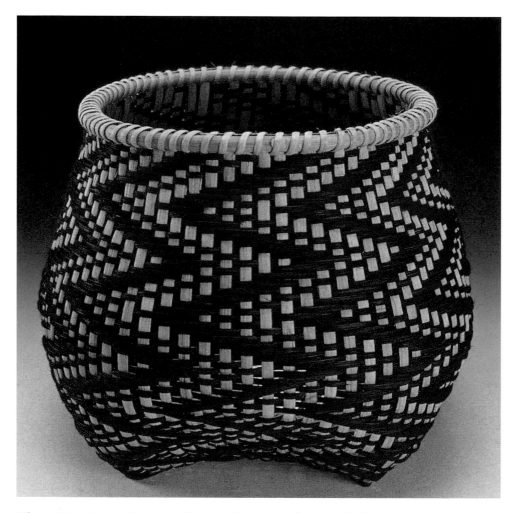

Fibonacci 8, 11"H × 14"W × 14"D. Henna and crushed walnut-hull dyed basket. *Photo by Melva Calder.*

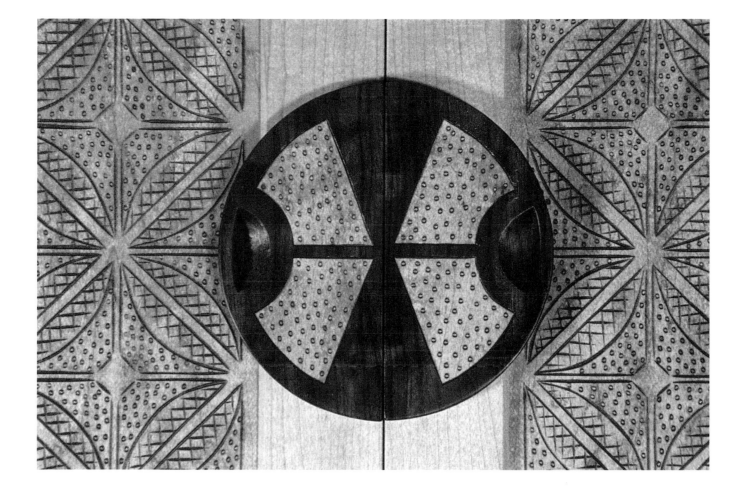

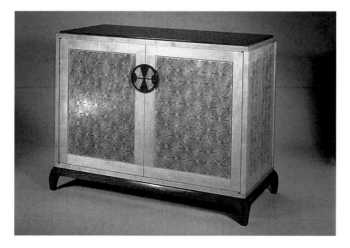

Criss Cross, 1998, 34"H × 42"W × 19"D. Maple and bubinga wood. *Photo by Shooting Star Photography.*

JANICE LESSMAN-MOSS, *If the Stars Didn't Shine on the Water* (detail), 1997, 66"H × 66"W. Linen, cotton and wire. *Photo by Janice Lessman-Moss.*

GARY FEY, *Singing Bowl* (detail), 45"H × 36"W. Jacquard silk, hot-wax resist and handpainted Procion. *Photo by Gary Fey.*

ERMA MARTIN YOST, *Planting Spirit* (detail), 1997, 33"H × 23"W × 3"D. Hand-printed fabrics with maple wood frame. *Photo by Noho Gallery.*

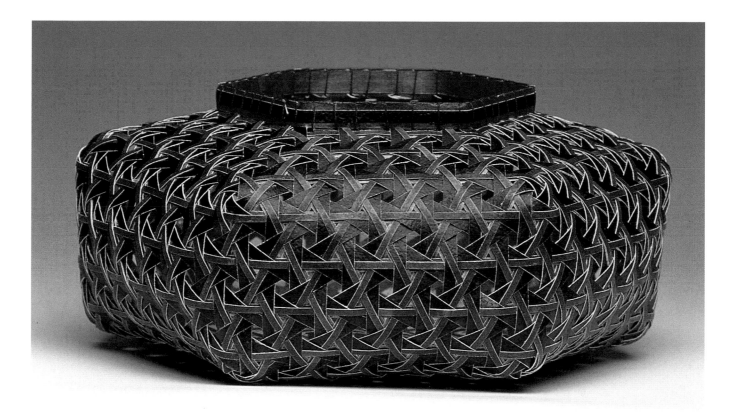

Hexagonal Weave #46, 6"H × 14"DIA. Paper, paint, varnish and waxed linen. *Photo by Greg Hubbard.*

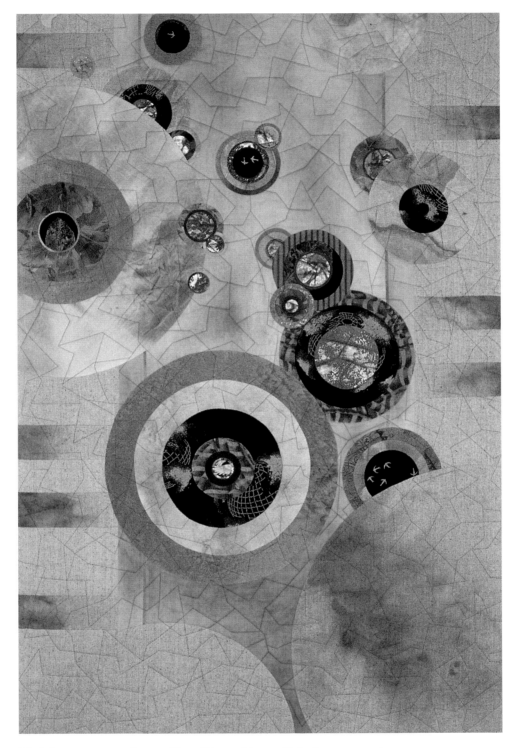

Rimini, 54"H × 37"w. Cotton, silk and linen with metallic leaf. *Photo by Joe Ofria.*

Mandarin Honey Sky (Vata #37), 1997, 48"H × 60"W. Acrylic on canvas.

Ancient Wisdom (detail), 1999, 32"н × 29"w. Wall piece of natural fibers and paper.

CHI, 1999, 15"H × 11"w. Oil on linen. Courtesy of TATE. *Photo by TATE.*

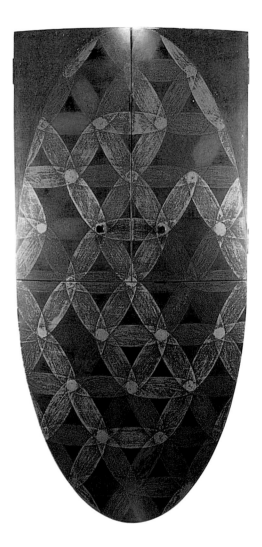

Gemini I, 47"H × 23"W × 6"D. Wall-hung cabinet of sustainably harvested Honduras mahogany, laminated Baltic birch ply and brass with biodegradable plant resin over milk paint finish.

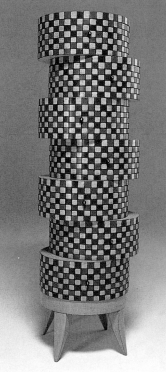

Hat Box Cabinet #5, 72"H × 21"W × 18"D. Solid mahogany with a milk paint mosaic finish. *Photo by Phil Harris.*

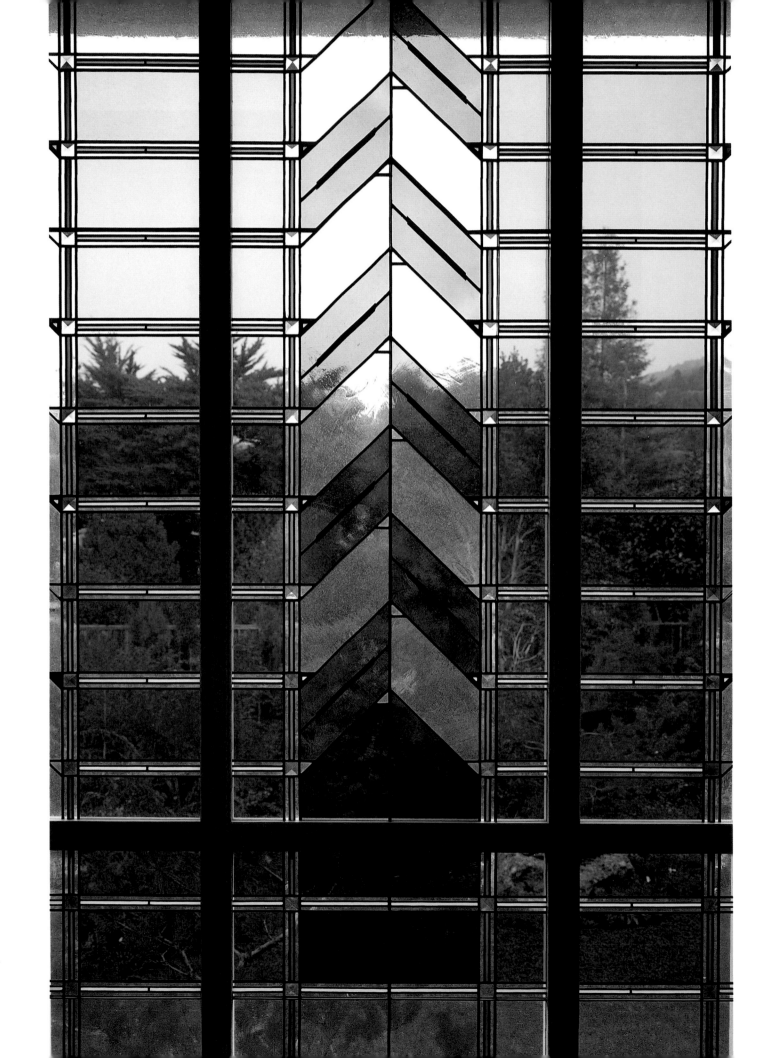

ARTHUR STERN ■ IVO LILL

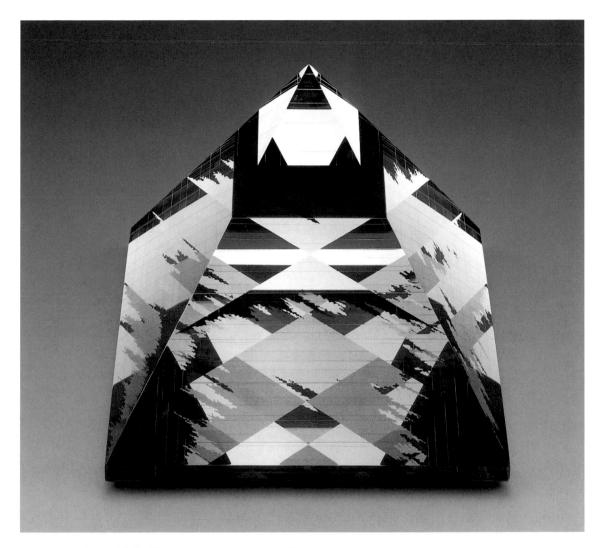

IVO LILL, *Pyramid (Red)*, 1998, 7"H × 7"W × 7"D. Glass. *Photo by Miel Verhasselt.*

OPPOSITE
ARTHUR STERN
Stair landing window, 10'H × 6'W.
Leaded glass with beveled glass prisms.
Photo by Larry Harrell.

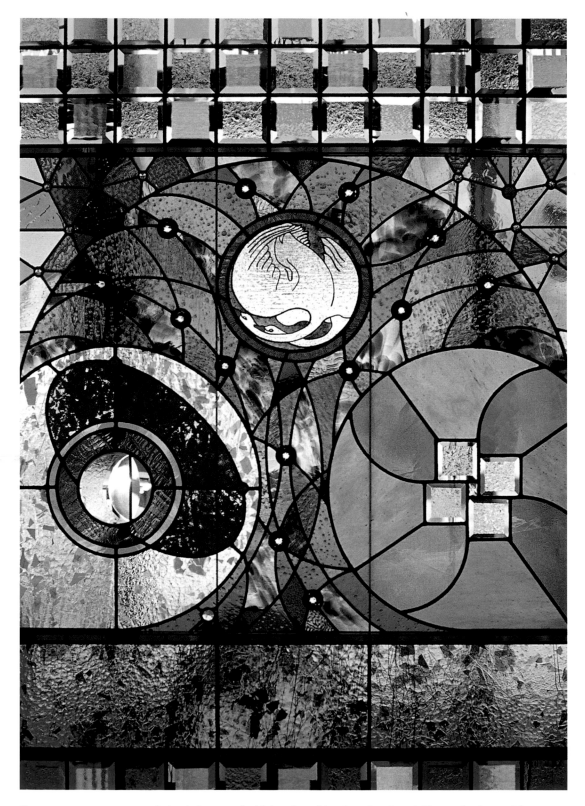

Swans, 1999, 54"H × 38"w. Stained glass panel with bevels and jewels, painted medallion and oak wood frame.

JEAN WOLFF, *Chiron* (detail), 1998, 48"H × 48"w. Acrylic on wood panel. *Photo by John Berens.*

AMY CHENG, *Unified Field Theory*, 1997, 24"H × 24"w. Oil and silkscreen on canvas.

JACK TWORKOV, Untitled (detail), 1982, 28"H × 27"w. Four-color lithograph. Courtesy of Lakeside Gallery.

KATHERINE STEICHEN ROSING, *Twilight*, 1998, 16"H × 14"w. Acrylic on canvas. From the *Deluge* series.

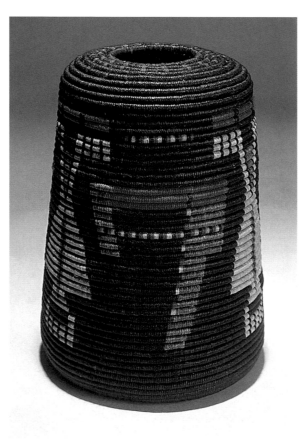

Ritual Basket, 1998, 7"H × 5"W × 3.75"D. Knotted and waxed linen basket. Courtesy of Katie Gingrass Gallery.

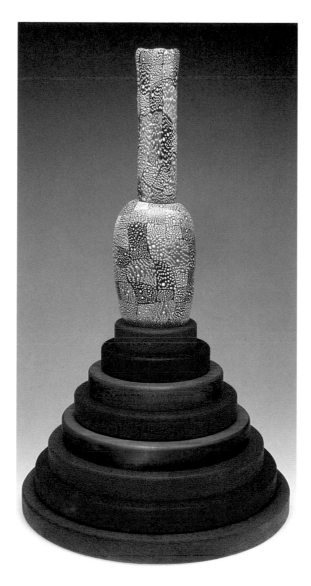

Granulare Bottle on Pyramid Puzzle, 1999, 34.5"H × 20"DIA.
Blown glass and stained wood. Courtesy of Elliott Brown
Gallery.

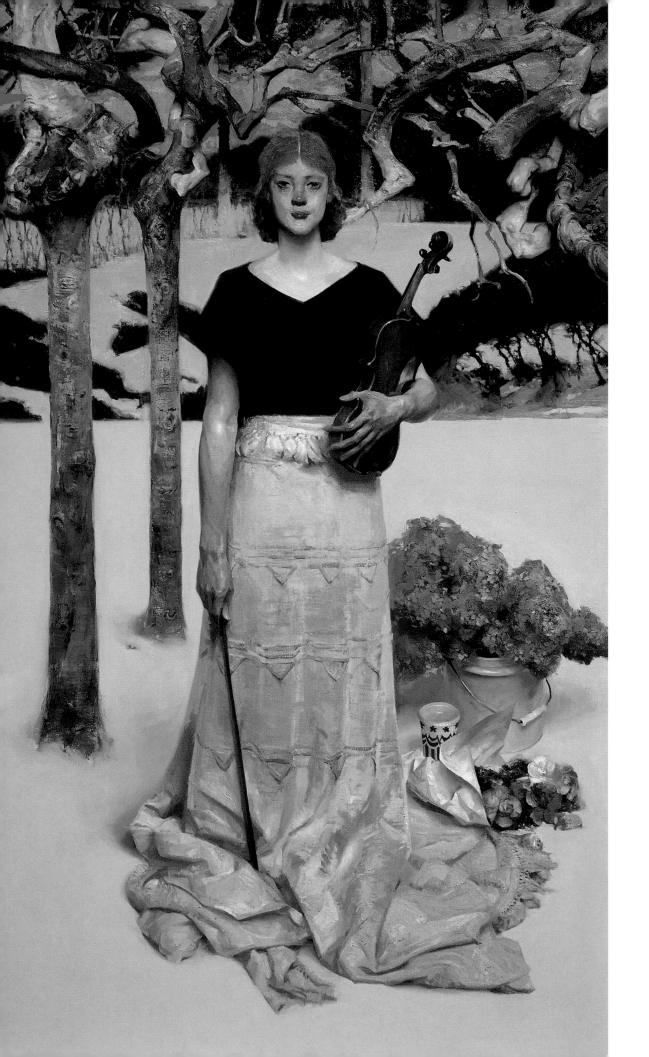

NEIGHBORS AND STRANGERS

As AMERICAN CULTURE CHARGES pell-mell into the 21st century, it is satisfying to see some artists holding on to the overlooked charms of traditional community. It is an index of the rapid pace of social and technological change that some of their pictures seem so cloaked in nostalgia. This sense of introspection descends from the Dutch genre pictures of the 17th century — the work of painters like Vermeer, whose images looked nostalgic even when the paint was wet on his canvas. Like those eminently subtle images, paintings of community today explore everyday events as a way of discovering unexpected psychological depth. If we are drawn into the silent drama of a figure gazing meditatively out the window, it is precisely because we are left with more questions than answers.

OPPOSITE
PAUL RAHILLY
The Performer, 1985, 84"H × 48"w.
Oil on canvas.
Photo by Paul Rahilly.

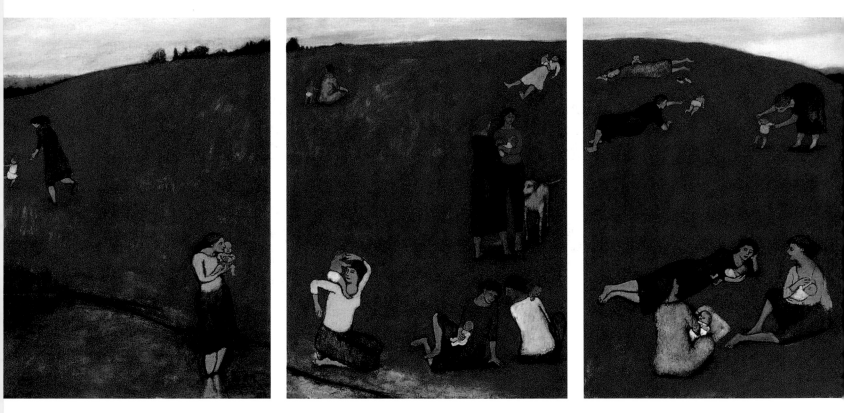

Women with Infants, 1998, 54"H × 126"W. Triptych. Oil on board. Each panel measures 54"H × 42"W.

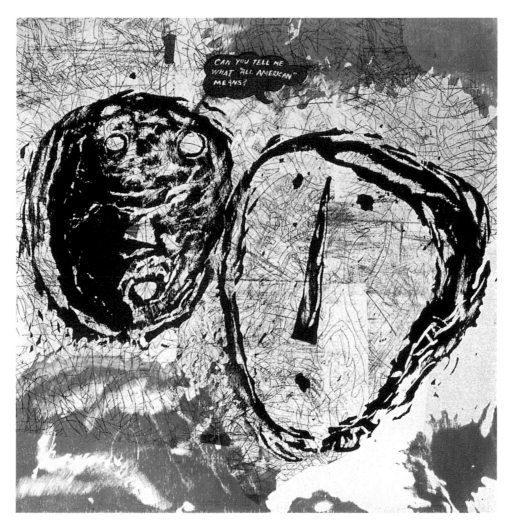

All American, 1996, 29.5"H × 29"w. Lithograph and woodcut print. Courtesy of Tandem Press.
Photo by Greg Anderson/Jim Wildeman.

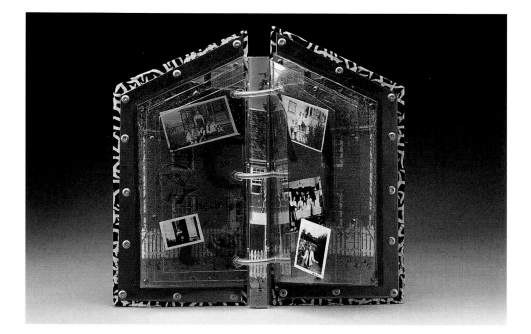

JOANNE FOX, *Home Is Where the Heart Is,* 16"H × 18"W × 2"D. Mixed-media sculpture with a copper and fabric cover and polycarbonate pages. *Photo by Hap Sakwa.*

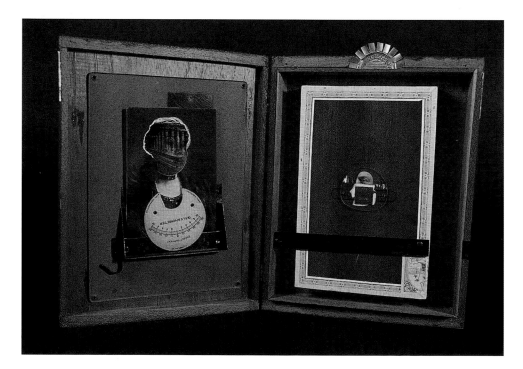

WALTER HAMADY, *Box #185 (necessity derives from no astronomical fact),* 1997, 12"H × 18"W. Freestanding box.

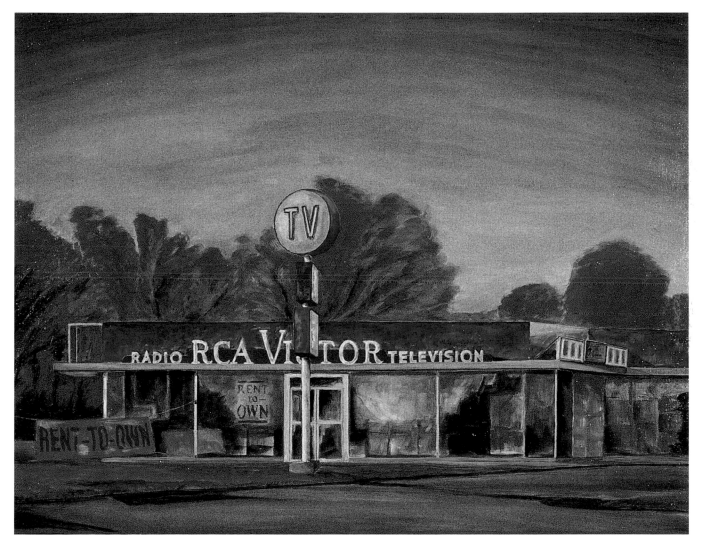

Rent to Own, 1997, 24"H × 30"w. Oil on linen.

Unpacking the Image, 1998, 34"H × 30"W. Oil on canvas.

Rock of Ages, 1997, 15"H × 22"w. Watercolor on paper.

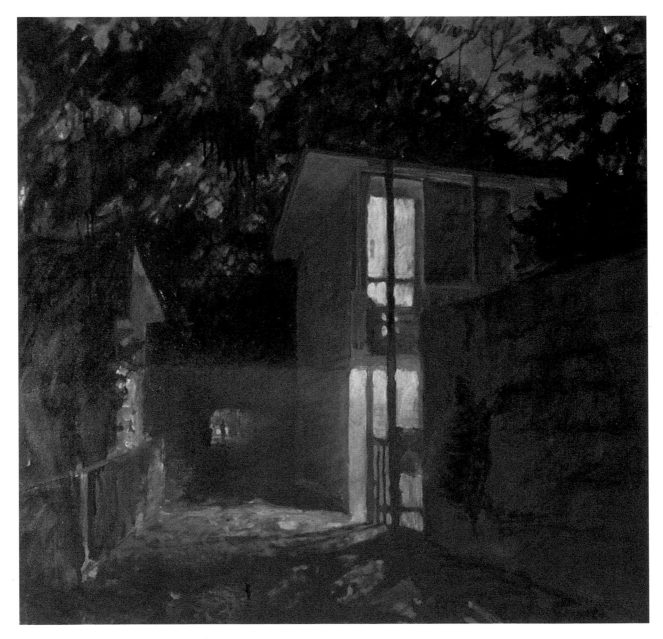

Riverside Alley, 1985, 34"H × 32"w. Oil on canvas.

Scylla & Charybdis, 1998, 40"ʜ × 48"ᴡ. Pastel on paper.

Priestess of Pompeii. Cibachrome gallery print.

Dancer, 13"H × 12"W. Silver gelatin print on fiber paper.

Time Piece: Millennium, 1998, 51"H × 40"w. Dyed and painted quilt. *Photo by Roger Schreiber.*

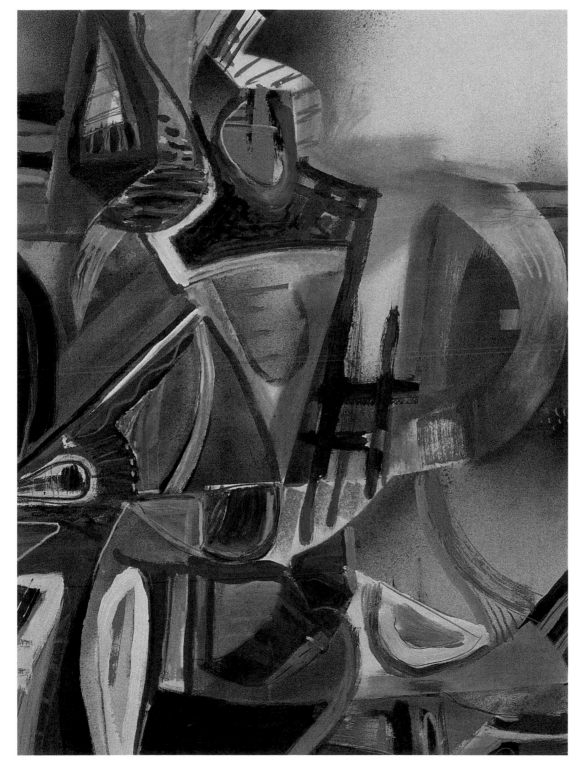

Face in the Crowd, 1996, 30"H × 22"W. Mixed media on paper.

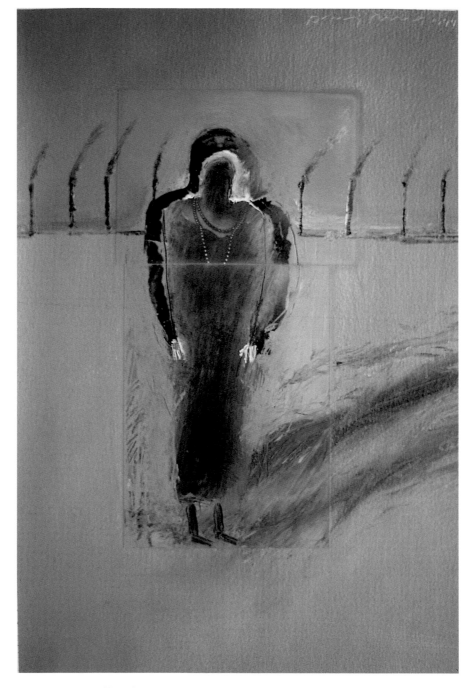

Woman Being Followed, 1995, 17"H × 12"W. Oil on gelatin silver print on paper.

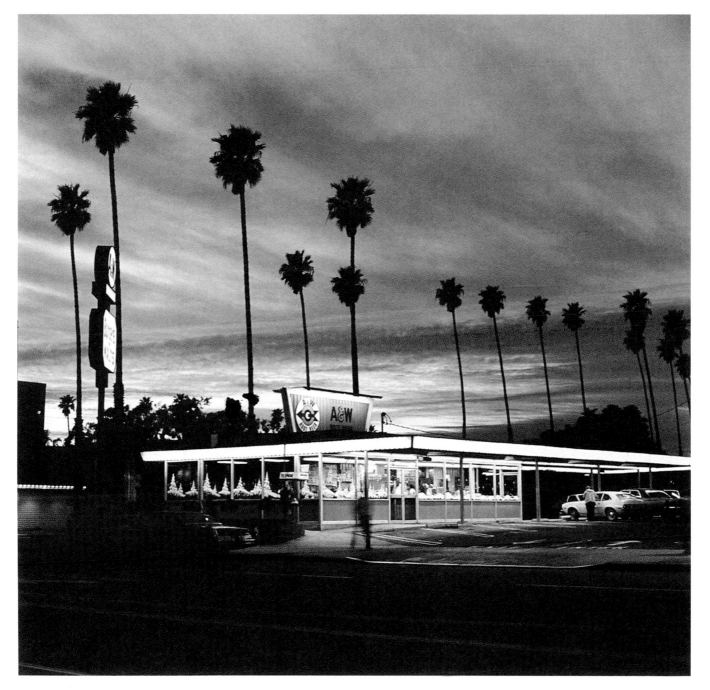

A & W, 1974, 15"ʜ × 15"ᴡ. Black-and-white silver gelatin photograph from the *Southland* series.

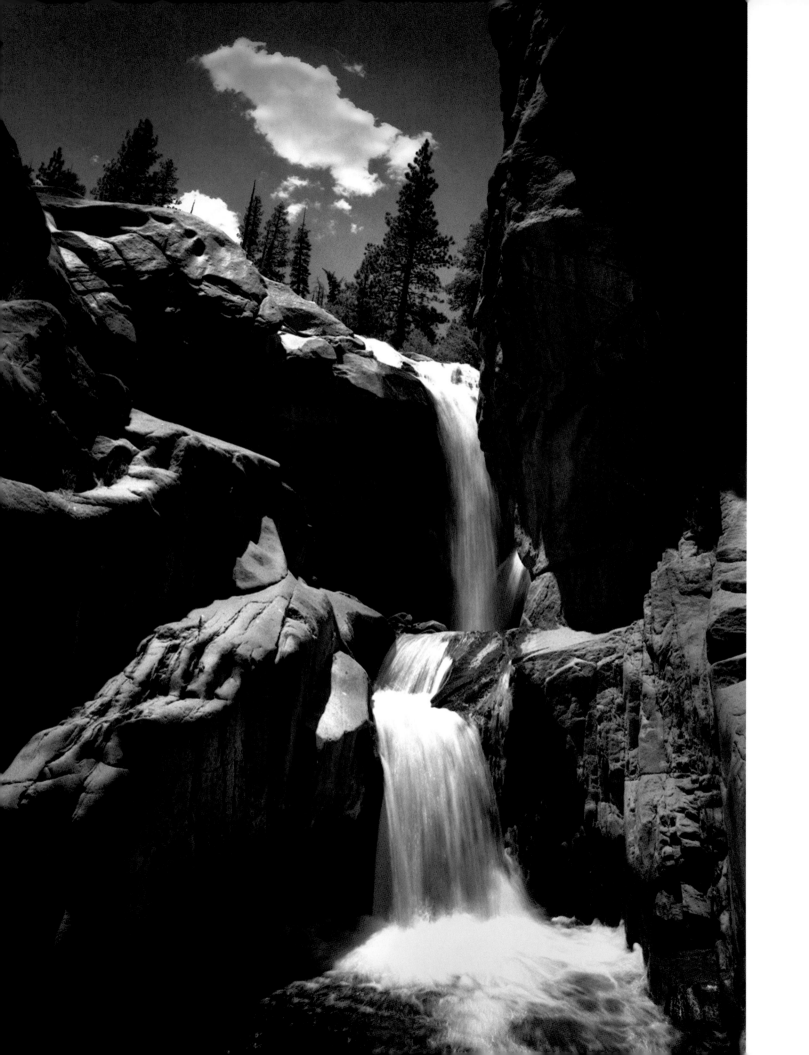

THE NATURAL WORLD

IN THE HISTORY OF AESTHETICS, there is a great divide: on the one side, the beauty that is fashioned by people, and on the other side, the great and wondrous world of natural beauty. Many of the most influential philosophers of beauty, such as Immanuel Kant, gave barely a moment's thought to art. They were more interested in the delicate beauty of a flower, the awe-inspiring majesty of a towering mountain peak or churning ocean. Artists have long conducted a tentative dance with the overpowering beauty of nature, unable to duplicate it, but also unwilling to turn away from the challenge of engaging with it. In the process, they create landscapes that are less about the mere appearance of the environment than our relationship with it.

OPPOSITE
RON GALLMEIER
Kern River Falls.
Black-and-white photograph.

FRED BENDHEIM ■ YOSHI HAYASHI

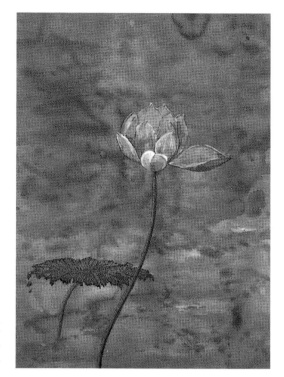

FRED BENDHEIM
Third Level, 1997, 30"H × 22"W.
Watercolor on paper.

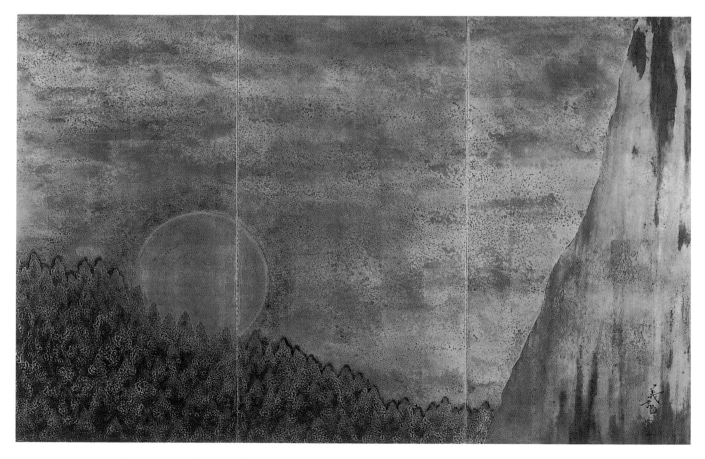

YOSHI HAYASHI, *Rising Moon,* three panels, total size: 46"H × 72"W. *Photo by Ira D. Schrank.*

136

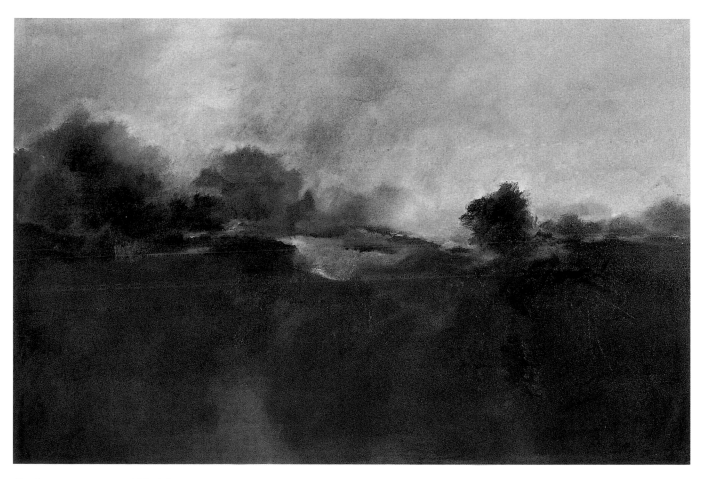

October, 40"H × 60"W. Oil stick on canvas. *Photo by Cynthia Howe.*

Civilization (detail), 1999, 50.25"H × 28"w. Dyed fabric wall piece.

Sacrifice (detail), 1998, 35"H × 54.5"w.

Space/Time (detail), 1999, 28"H × 47"w.

Flame (detail), 1997, 31.5"H × 67.25"w. *Photos by Lucy A. Jahns.*

A Place and Time (detail), 42"H × 38"w. Wool, linen, silk and rayon. *Photo by Hap Sakwa.*

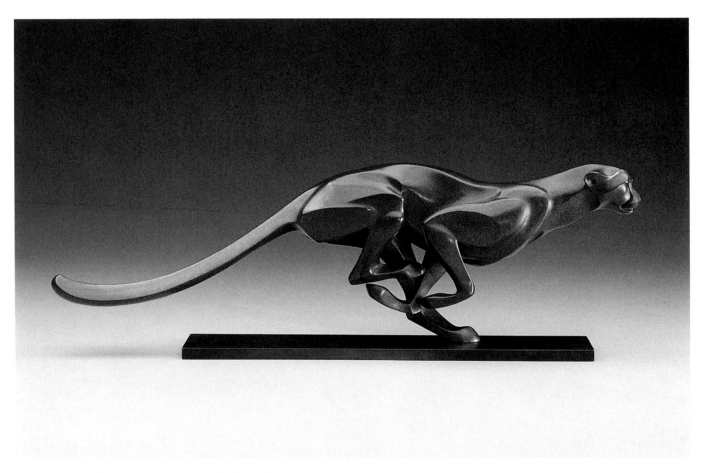

Running Cheetah, 6.75"H × 20"W × 3"D. Patinated bronze. *Photo by Mel Schockner.*

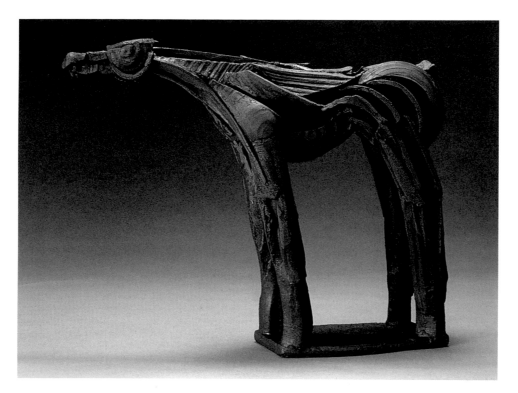

Long Kawai Tribute, 1999, 20"H × 25"W × 7"D. Earthenware.

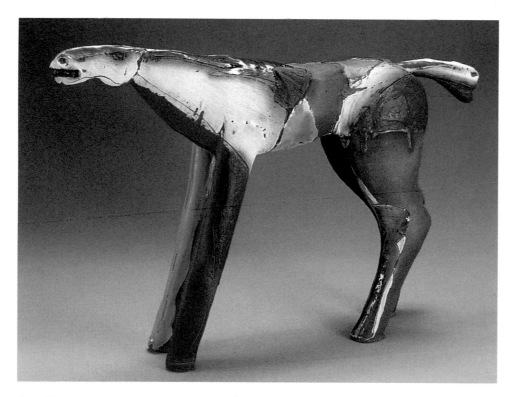

Long Horse, 92-29, 18"H × 21"W × 5"D. Earthenware. *Photo by Jeri Hollister.*

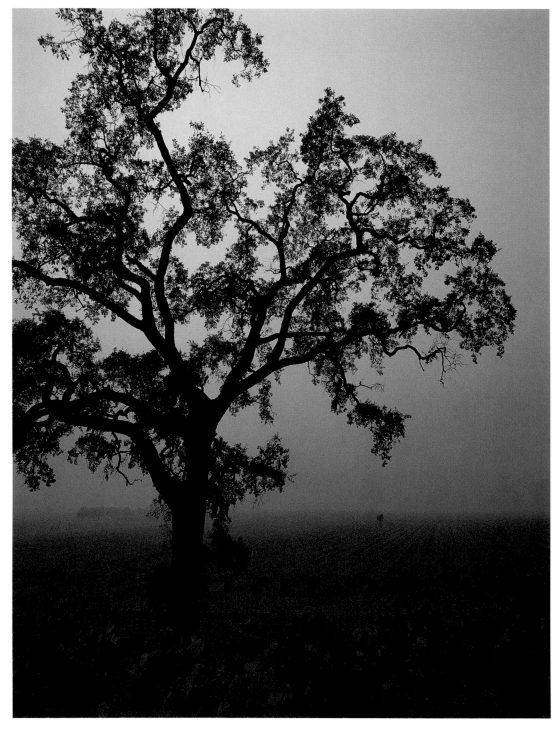

Napa Valley, 11"H × 14"w. Ilfochrome print.

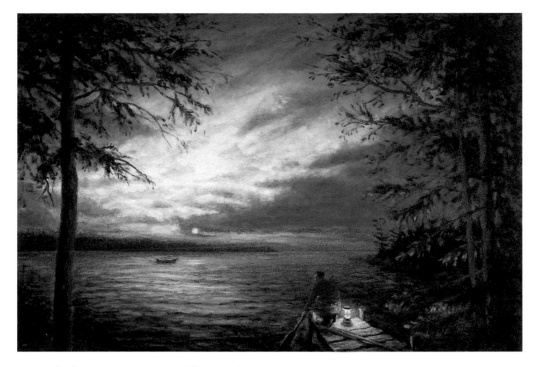

Late Arrival, 1999, 22"H × 29"w. Oil on panel.

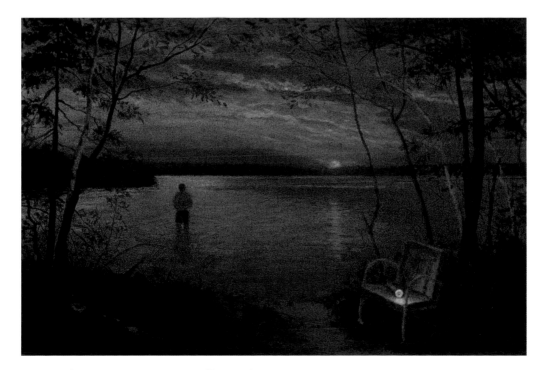

Between Places, 2000, 22"H × 29"w. Oil on panel.

Afternoon Procession, 1993, 30"ʜ × 22"ᴡ. Oil on paper.

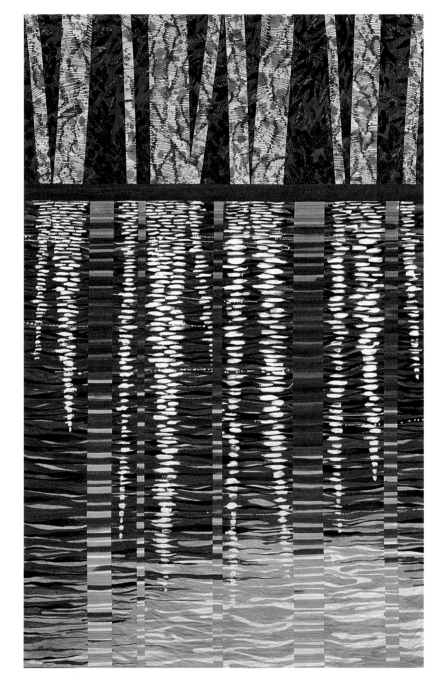

Still Water, 1991, 8.33'ʜ × 5.17'ᴡ. Cotton, dye and pigment. *Photo by Mark Frey.*

Three Chrysanthemums, 1999, 42"ʜ × 50"ᴡ. Oil and acrylic on canvas. *Photo by John Clines.*

Waterbugs, 1999, 48"ʜ × 48"ᴡ. Oil on canvas.

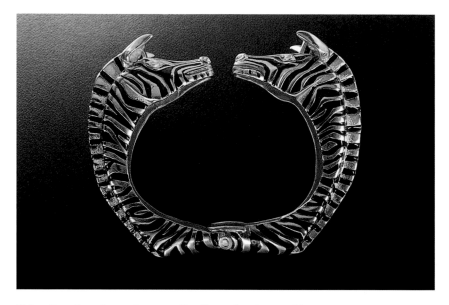

Zebra Bracelet, 4"H × 4"W × 0.18"D. Enamel and 18K gold. *Photo by Glenn Moody.*

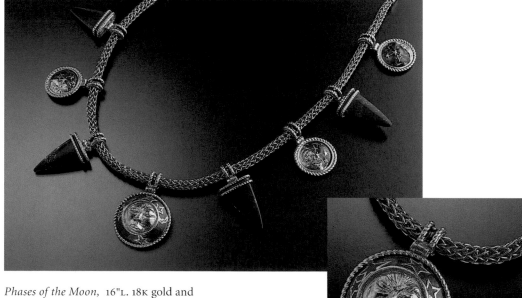

Phases of the Moon, 16"L. 18K gold and
lapis lazuli stones. *Photos by Allen Bryan.*

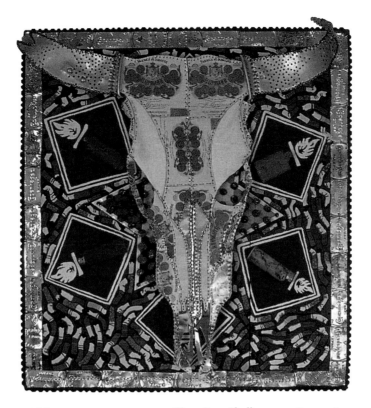

ROSS PALMER BEECHER, *Cigar Steer Skull*, 1995, 24"H × 21"W × 7"D. Sculptural wall piece of oil on carved wood, cigar tins and other found objects. *Photo by Ross Palmer Beecher.*

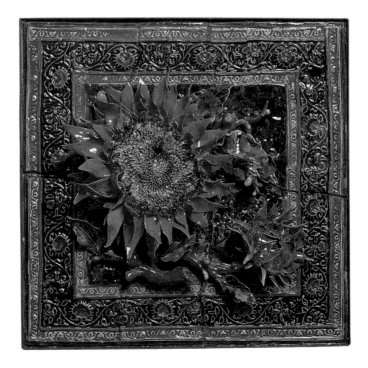

GEORGE ALEXANDER, *Tapestry Series: Sunflower*, 24"H × 24"W × 8"D. Ceramic sculpture of stoneware on welded steel. Courtesy of Handsel Gallery. *Photo by Peter Kahn.*

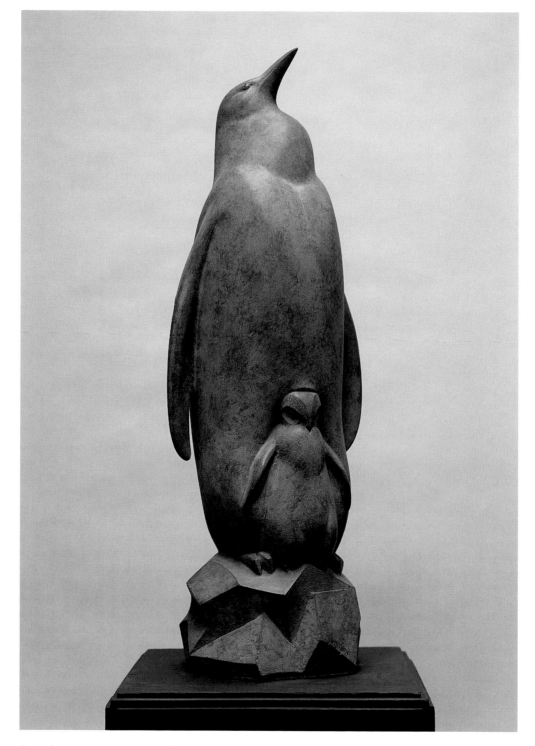

Penguins, 1994, 44"H × 17"w. Bronze. *Photo by Bob Taylor.*

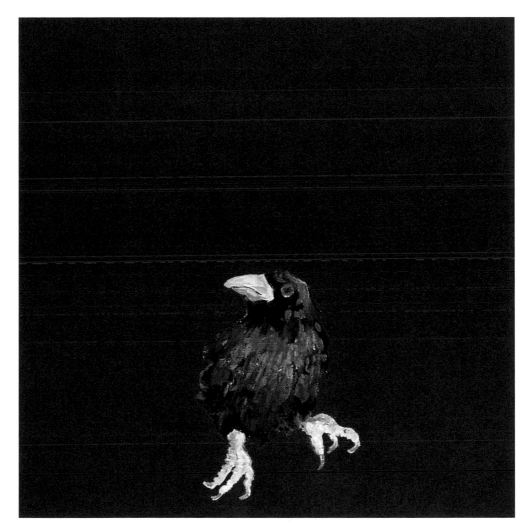

Fledgeling Crow #7, 1999, 12"ʜ × 12"ᴡ. Oil on canvas.

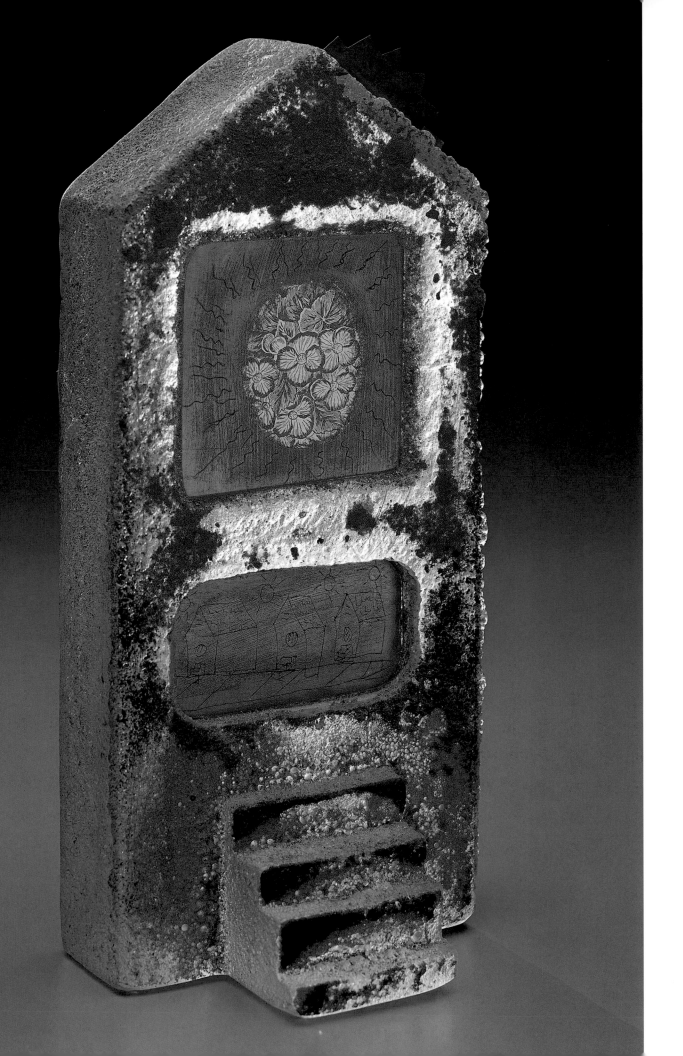

CHERISHED OBJECTS

As ANY MUSEUM CURATOR WILL TELL YOU, objects get more valuable as time goes by. This is true not only for ancient artifacts: longevity means something, too, in the case of the most personal possessions. That this is a very private kind of value, perhaps impossible for others to fully understand or share, makes it all the more meaningful. This is why the best craftspeople design their pieces to be kept forever. They want their pieces to take on the patina that comes from years of touching and acquire the small breaks and tears that accumulate over the years. Most of all they hope that their work will become, eventually, an occasion to remember.

OPPOSITE
VINCENT LEON OLMSTED
She Loved Begonias Growing on Her Block,
1999, 12"H × 6"W × 4"D.
Sandcast glass, gold leaf, book illustrations,
windowpane, copper and hand engraving.

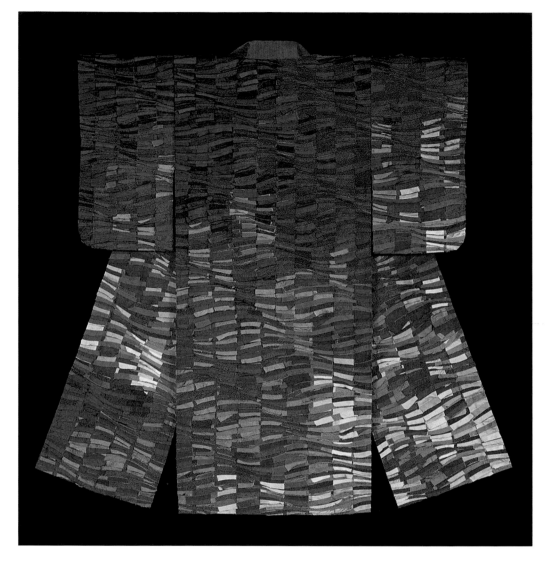

Green Wave Kimono, 1999, 64"ʜ × 62"ᴡ. Layered, stiched and cut silk wall hanging.

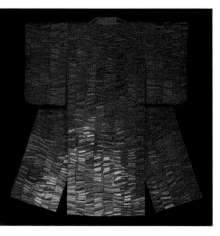

Golden Wave Kimono, 64"ʜ × 62"ᴡ.
Multilayered silk wall hanging.
Photo by Petronella Ytsma.

Temple Form, 1999, 18.5"DIA. Terra cotta wall piece of wheel-thrown colored clays, slips and vitreous engobes.

Arcadia Rush, 1999, 11"DIA.

Temple Form VII, 1999, 13"DIA.

Cappadocia II, 18"DIA. *Photo by Susanne Stephenson.*

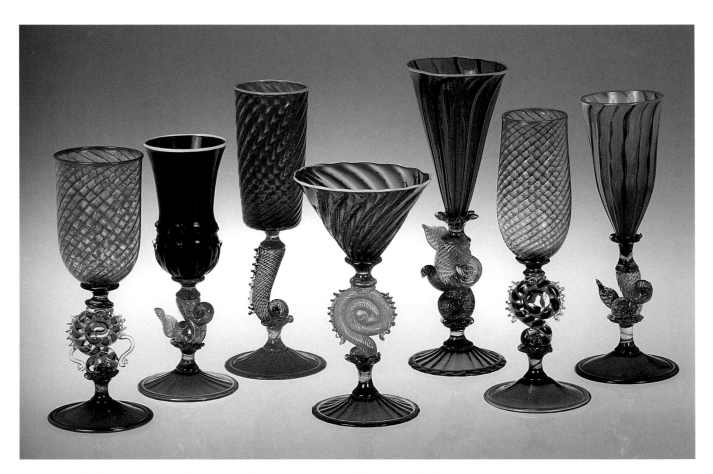

Tutti Frutti Goblets, 7"H TO 9"H. Hot-formed, blown and hot-assembled glass rod goblets. *Photo by Paul Turnbull.*

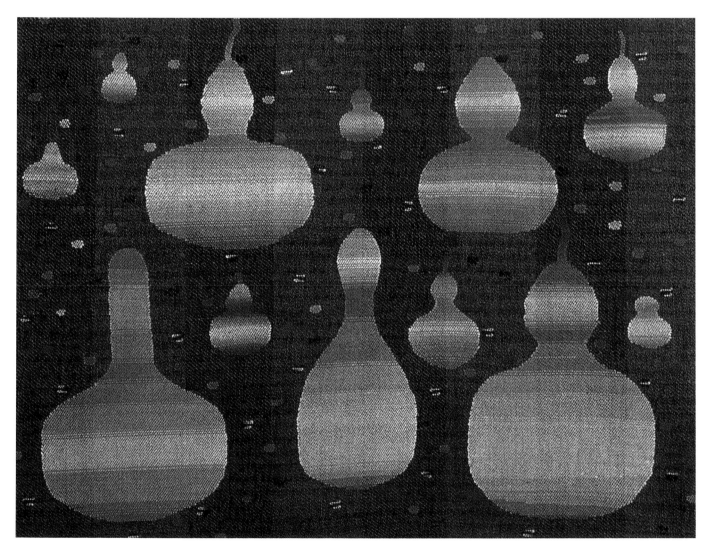

Bottle Gourds (detail), 1995, 25"H × 31"w. Handwoven cotton and wool brocade wall hanging. *Photo by Garry Henderson.*

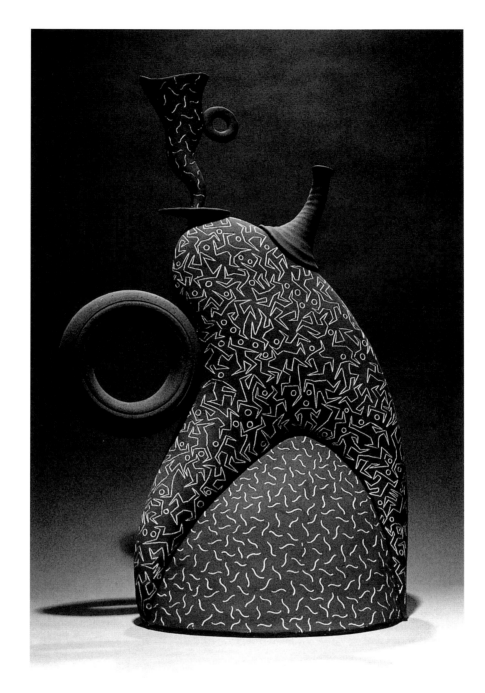

Figure Tea Set with Ring, 15"H × 8"W × 3"D. Ceramic with black slip and a sgraffito design.

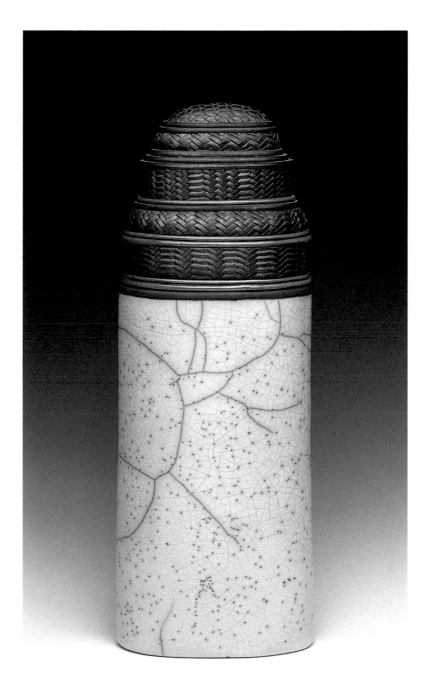

Torre Blanca, 20"H × 7"W × 6"D. Raku-fired ceramic vessel with lid.
Photo by Jerry Anthony.

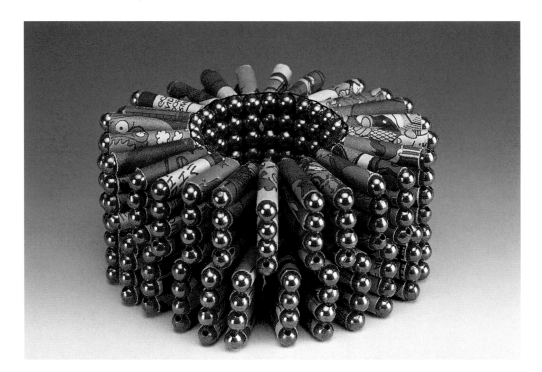

The Joke's on You, 4.5"H × 4.5"W × 2.5"D. Sunday comics, brass bead trim and elastic cord bracelet.

Photo by Jerry Anthony.

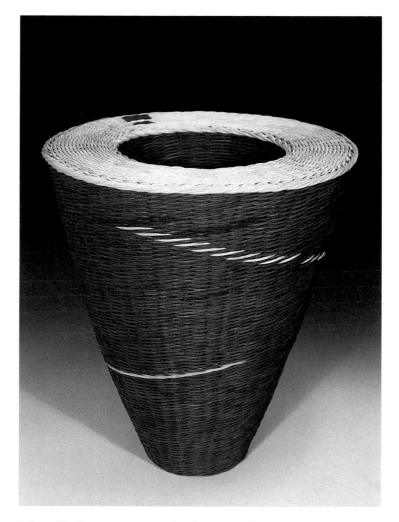

Winter Tracks, 17"H × 15"DIA. Dyed rattan reed. *Photo by Kari Lønning.*

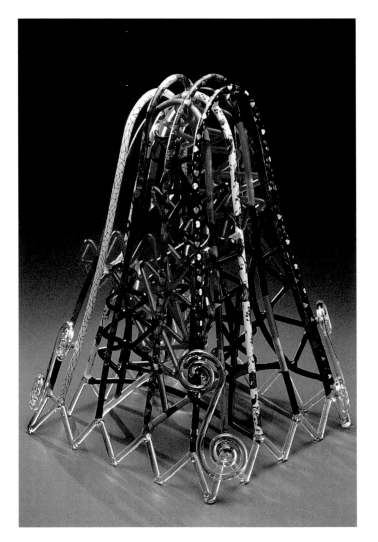

Decorative Leaf Igloo, 1998, 25"H × 19"W × 17"D. Lampworked glass and painted Pyrex. Courtesy of R. Duane Reed Gallery.

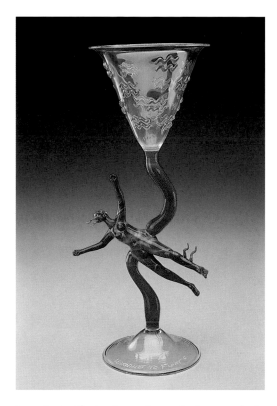

Learning to Float, 9"H × 4"W × 4"D. Lampworked goblet.

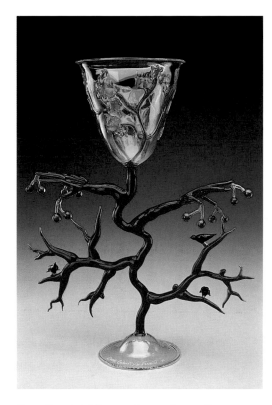

Door County's Finest, 11"H × 9"W × 4"D.

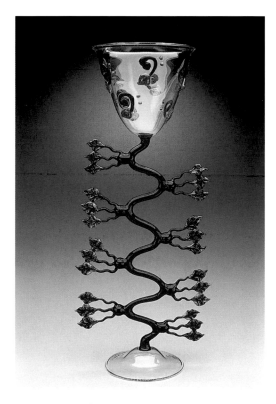

Eight Beets to the Bar, 1996, 12"H × 6"W × 4"D.

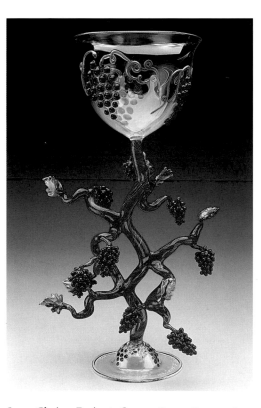

Some Choices Easier to See, 1998, 10.5"H × 7.5"W × 4.5"D. *Photos by William F. Lemke.*

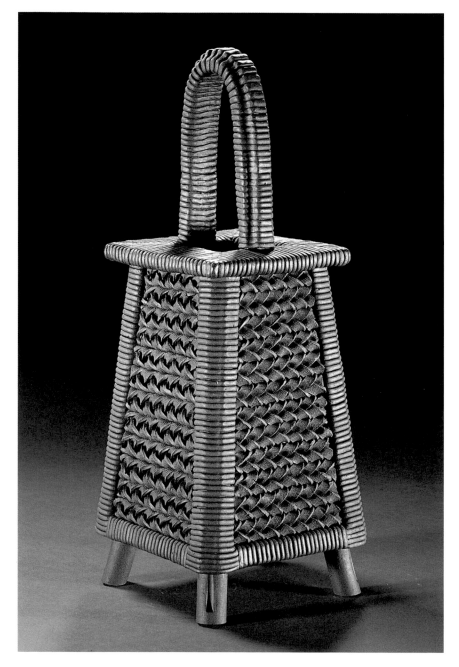

Red & Black Basket, 17"H × 6"W × 6"D. Red and black clay basket.

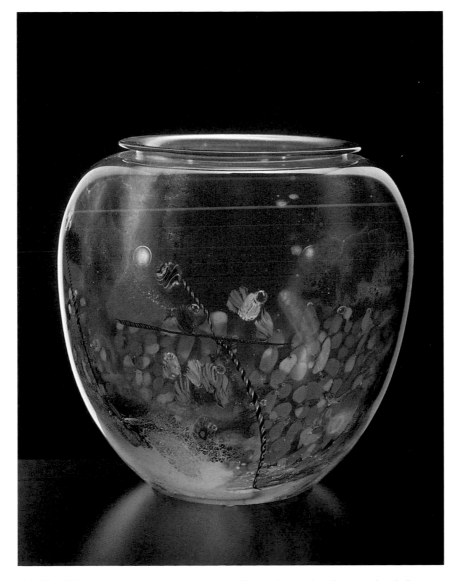

Inhabited Vase 8.8.96, 1996, 7.5"H × 7.5"DIA. Blown glass, colored or powdered glass, cane and gold leaf. *Photo by Tommy Olof Elder.*

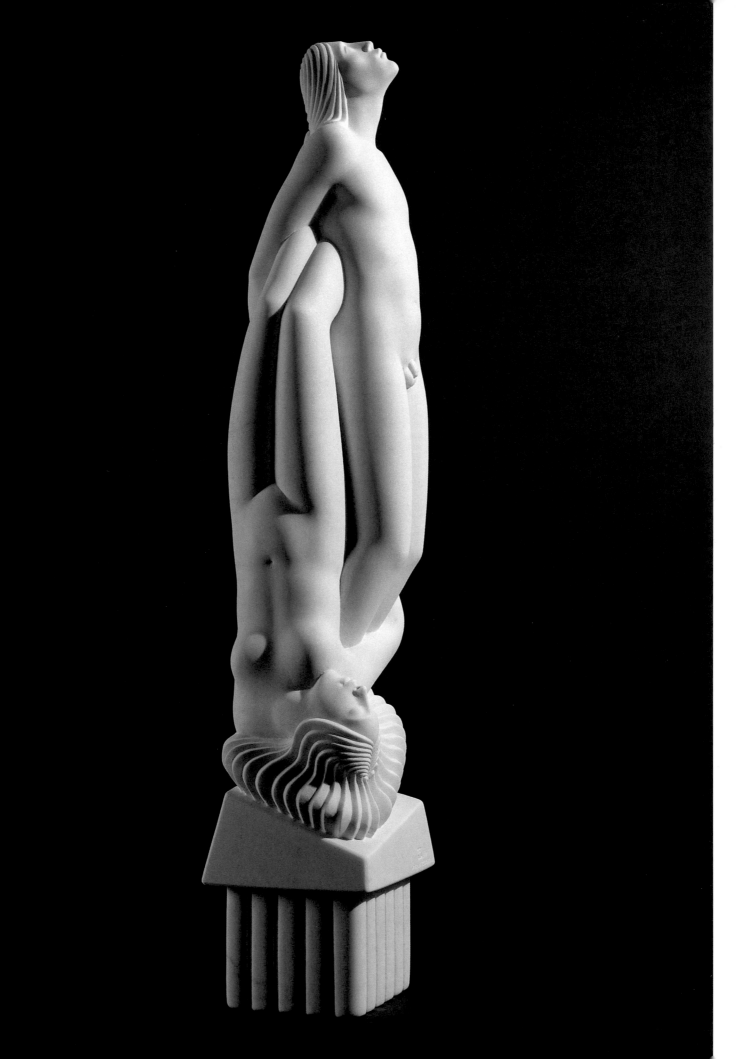

PURE BEAUTY

AFTER ALL THE UPS AND DOWNS OF PURITY in 20th-century art, there is still something immovable about the appeal of it. It is the rock on which all aesthetics stand. The clean, the primary, the unadulterated — all are unlikely ever to go truly out of fashion. But it is easy to forget that this, the simplest kind of beauty, is also the most austere and exacting, and therefore the most difficult to achieve. As they say, cleanliness is next to godliness, and the matter of injecting new life into purism is definitely a tough nut to crack. Artists are ever on the search for new materials and processes that, when discovered, may lead to an opportunity for a new type of refinement.

OPPOSITE
VASILY FEDOROUK
Children of Paradise,
1999, 36"H × 7"W × 7"D.
Marble.
Photo by Richard Nicol.

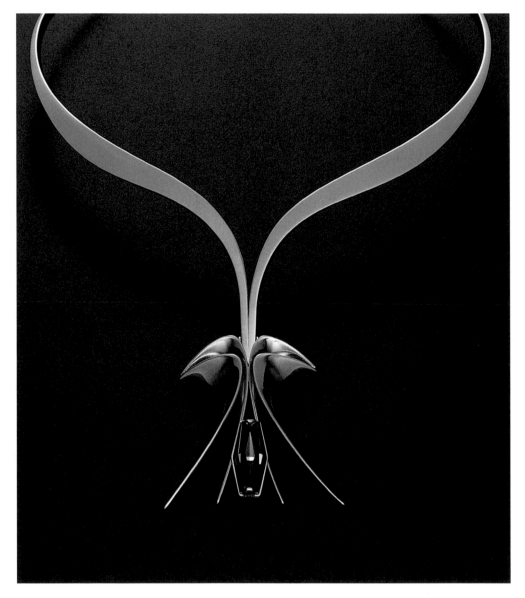

Neckband 18-24B, 5.25"w × 0.5"d × 8"l. Forged 14k yellow gold with amethyst gemstone. *Photo by William Thuss.*

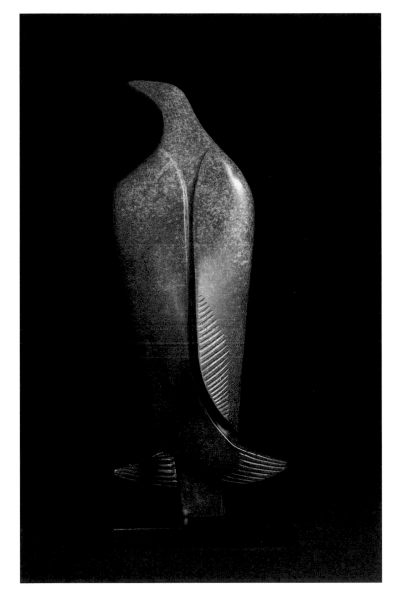

Evermore, 1998, 66"H. Bronze. *Photo by Bob Kohlbrenner.*

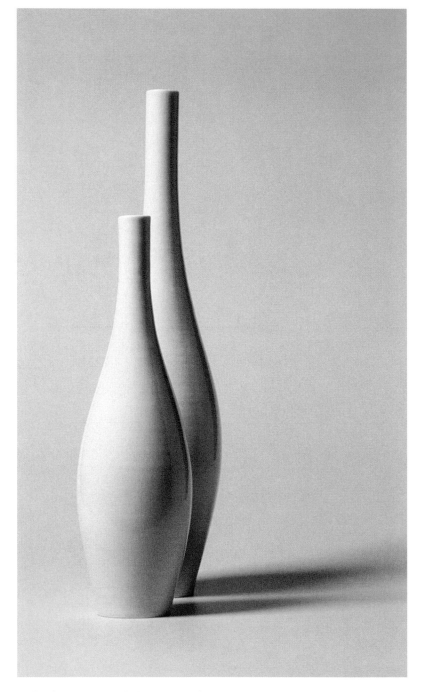

Still Life, 40"H. Wheel-thrown porcelain. *Photo by Michael Harvey.*

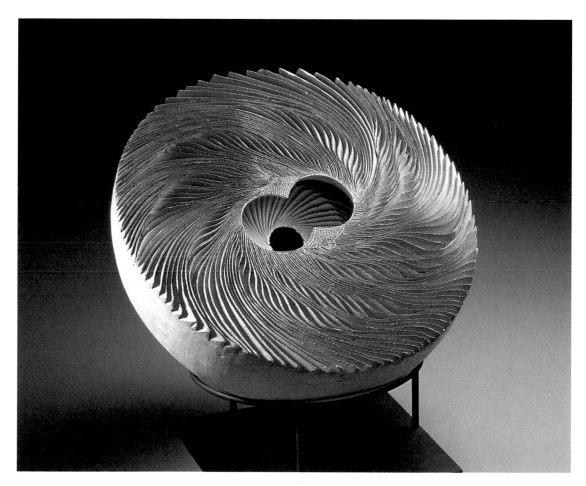

Hemisphere, 8"H × 12"DIA. Ceramic. *Photo by Eva Heyd.*

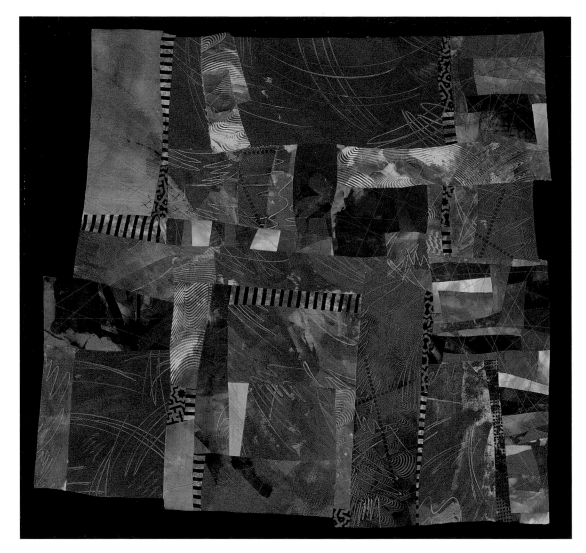

Abiquiu Reconstructed, 1997, 37"H × 47"W. Hand-dyed and painted fabrics and handpainted canvas.

Photo by Ken Sanville.

Winter Yellows (detail), 41"H × 46"w. Hand-dyed, machine pieced and quilted cotton fabric.

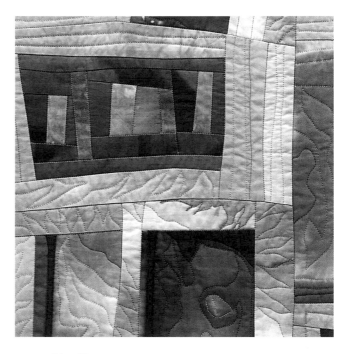

Lumen (detail), 51"H × 70"w.

Tender Green (detail), 46"H × 51"w.

Two Way Stretch: Shards (detail), 55"H × 61"w. *Photos by Ken Wagner.*

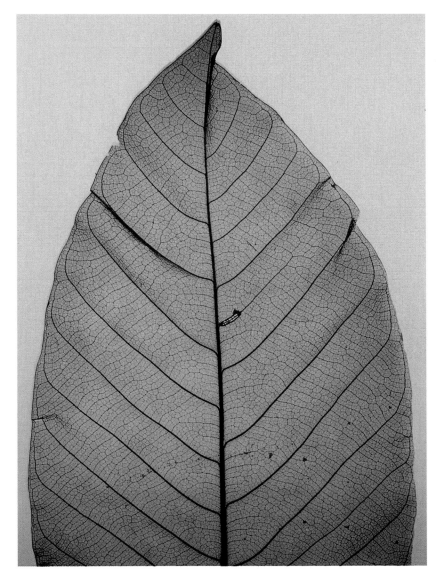

Leaf Half, 1999, 14"ʜ × 11"ᴡ. Fiber silver sepia-toned print.

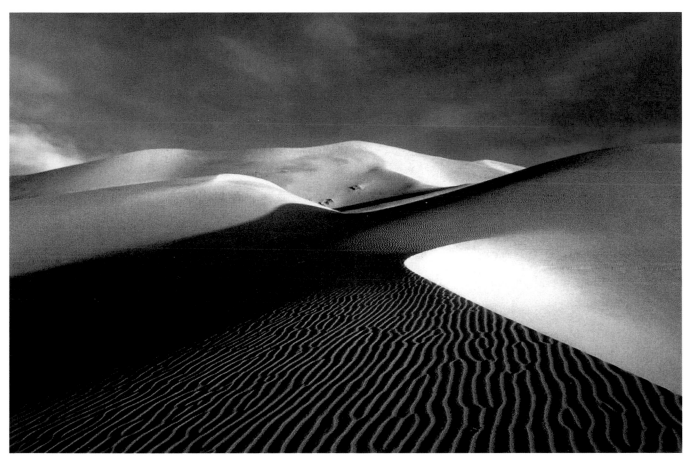

Death Valley Dunes, 8.25"H × 13"w. Handcolored black-and-white photograph.

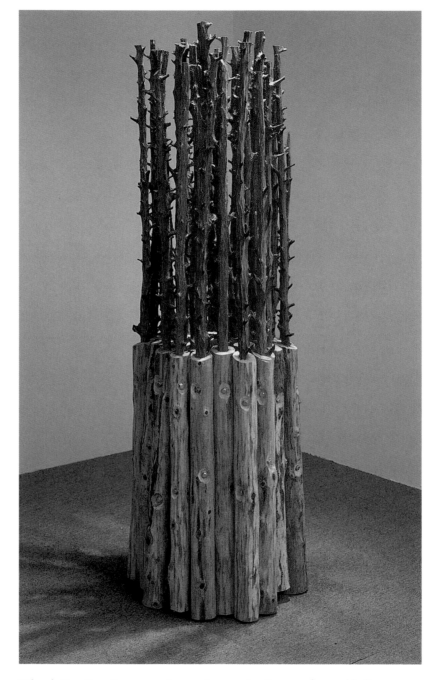

Where's Your Forest?, 1993, 72"H × 24"W × 24"D. Young cedars and bolts.
Photo by Joseph Hyde.

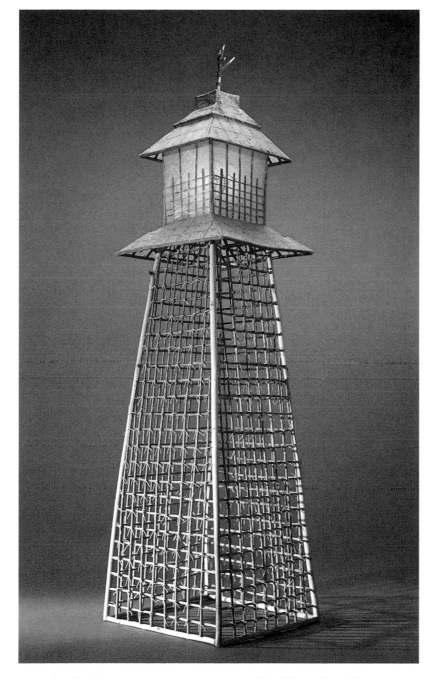

From the Watchtower, 36"H × 18"W × 18"D. Washi, willow and eucalyptus.
Photo by Jennifer Cheung.

Window, 48"h × 48"w. Stained glass.

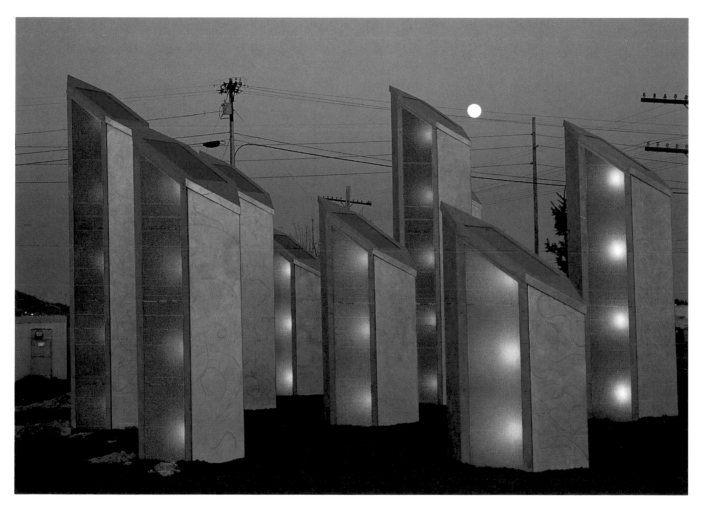

Solar Calendar, 1998, 14'H × 70'W × 25'D. Aluminum, LIGHTBLOCKS™ and solar panels.

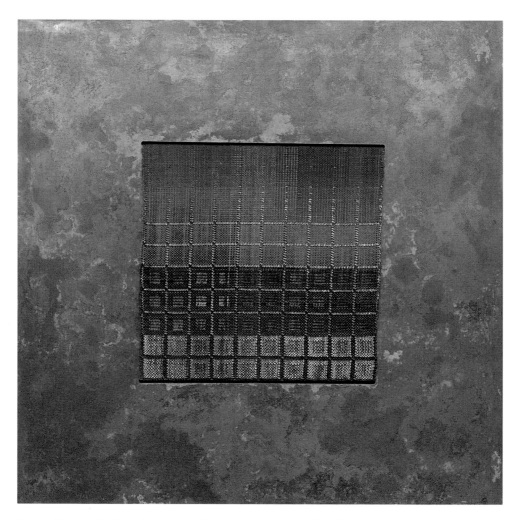

Lost in Fields of Gold, 20"H × 20"w. Wool, rayon, nylon and lightfast dyes. *Photo by Thomas Bruce.*

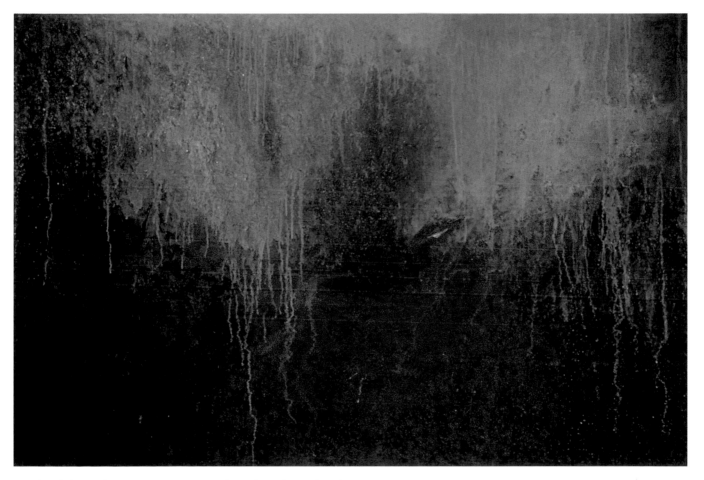

Smithy of the Soul, 1999, 48"w × 72"w. Oil, acrylic and mixed media on canvas.

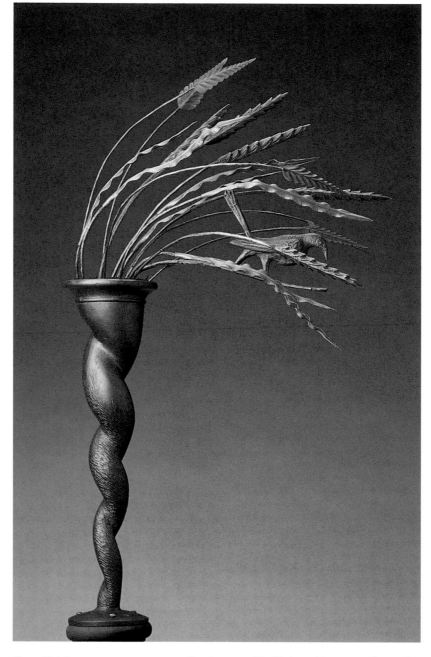

Ceres Finial, 20"ʜ × 5.5"ᴡ × 5.5"ᴅ. Cast bronze with fabricated bronze and rusted steel. *Photo by Jim Wildeman.*

Blue Composition, © 1991, 35.5"H × 14.5"W. Watercolor on Arches paper.
Courtesy of William Zimmer Gallery. *Photo by Lloyd Hryciw.*

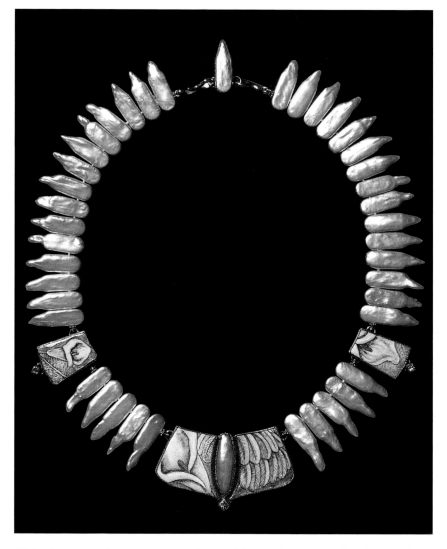

White Spring, 1.25"w × 17"L. 24K and 14K gold, grisaille and enamel necklace with Tennessee River pearls and princess-cut diamonds. *Photo by George Post.*

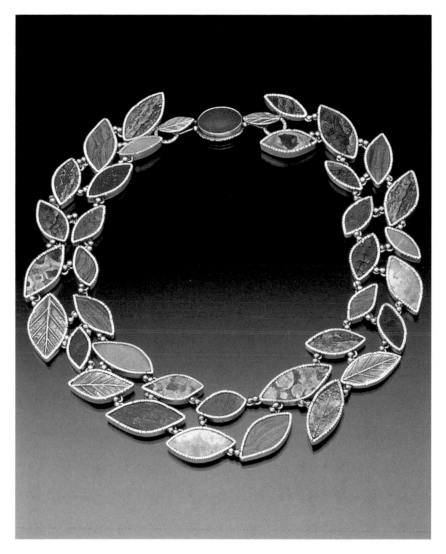

Leaf Choker, 2"w × 19"L. Semiprecious stones, sterling silver and bronze.
Photo by Doug Yaple.

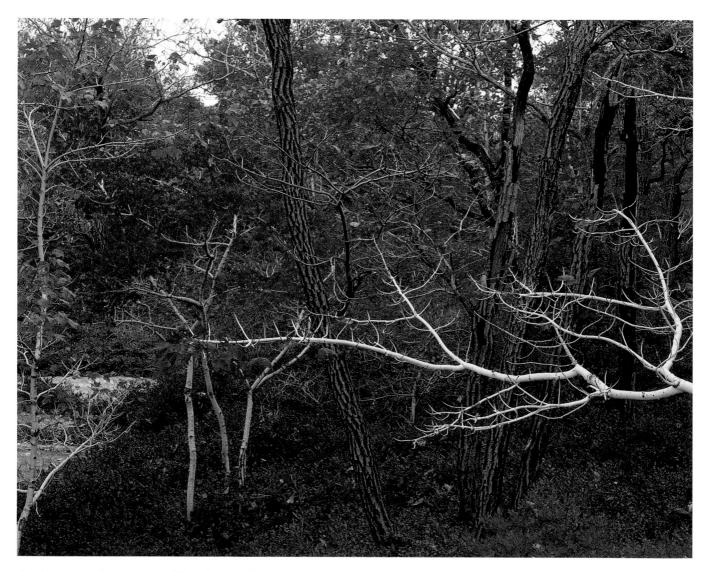

October 25, 1983 / 1 p.m., 1985, Color photograph. *Photograph © 2000 ROBERT GLENN KETCHUM.*

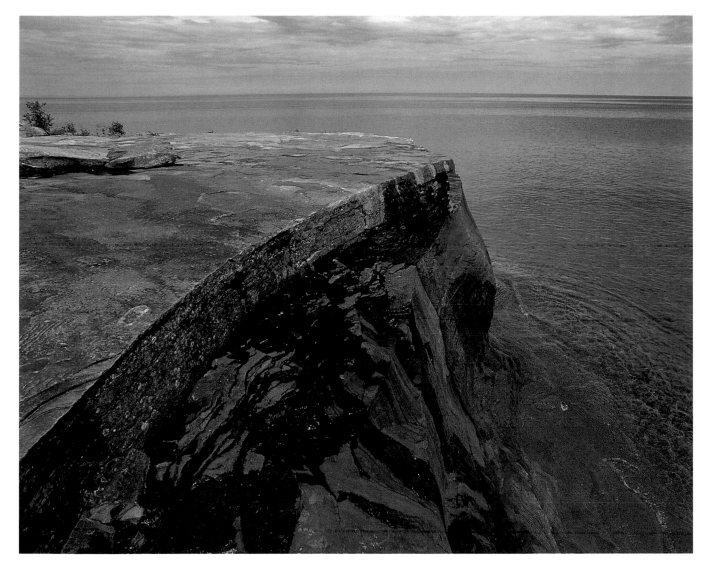

Devil's Island, Apostle Island, 16"H × 20"W. Ilfochrome photographic print.

ABOUT THE ARTISTS

■ **JACKIE ABRAMS**

Jackie Abrams' baskets are woven of heavyweight watercolor paper that she has decorated with painting, collage and print-making surface techniques. Each piece is created with a focus on the interplay of color, texture and surface design. ■ PAGE 95.

■ **JEANETTE AHLGREN**

Jeanette Ahlgren makes freestanding basket forms by weaving thousands of glass beads onto structures of finely woven brass, copper or stainless steel wire. The beads combine to form a tiny, brilliant tapestry of geometric or landscape images. ■ PAGE 180.

■ **GEORGE ALEXANDER**

George Alexander's ceramic vases, bowls, mirrors and architectural elements are rooted in the tradition of Italian majolica. They are richly glazed and exuberantly decorated with images of fruits, vegetables, flowers and foliage. ■ PAGE 157.

■ **BRETT ANGELL**

Brett Angell's paintings on canvas are completed in acrylic paint thinly layered to build up a waxy, finished surface; his paintings on paper are made in watercolor and gouache built up in layers over the colored ground. Collections include: Springfield Art Museum, MO; Sioux City Art Center, IA. ■ PAGE 151.

■ **DAWN ARROWSMITH**

Dawn Arrowsmith paints with pastry brushes and Asian toothpicks — using the small sticks to create a meditative field of fine, spice-like marks on the canvas. Her glowing and quietly dissolving works are derived from investigations of longevity, meditation, nature and light. Collections include: Capital Group Foundation, Los Angeles, CA; Security Pacific National Bank, Los Angeles, CA. ■ PAGE 97.

■ **GWEN AVANT**

Proficient in a variety of media, Gwen Avant often uses oil, beeswax, acrylic and chalk in the creation of her imagery. Boats and bowls regularly reveal their ghostly outlines on the surface of the canvas — traceably present but purposely remaining both visually and meaningfully obscure. ■ PAGE 150.

■ **HYE SUN BAIK**

Hye Sun Baik uses fiber-based mixed media to reproduce the depth and dimension of experience. She builds her canvas from a wide range of natural fibers and paper, using innovative casting, pulp painting, printing, embroidery and embossing methods. ■ PAGE 98.

■ **ALLAN BAILLIE**

Allan Baillie uses a large-format camera and Polaroid film to capture his wistful, finely detailed images. By adding toner during the printing process, he creates a warmth that pervades the seemingly still subject matter, making it come alive with light, shadow and depth. ■ PAGE 192.

■ **TIM & PAMALA BALLINGHAM**

The collaborative wall works of Tim and Pamala Ballingham are executed in clay and finished with clear, brilliant colors that vibrate in abstract, metaphoric landscapes. Perimeters are composed as sculptural elements, creating a bridge between painting and sculpture. Collections include: Renwick Gallery, Smithsonian Institution, Washington, DC; Sheldon Memorial Art Center, Lincoln, NE. ■ PAGE 53.

■ **BORIS BALLY**

Boris Bally recycles street signs and bottle caps to create furniture and bowls that are as tactile and beautiful as they are strong and unique. Collections include: Victoria and Albert Museum, London, England; Smithsonian Institution, National Museum of American Art, Washington, DC; American Craft Museum, New York, NY; Mint Museum of Craft + Design, Charlotte, NC. ■ PAGE 28.

■ **MICHAEL & MAUREEN BANNER**

Michael and Maureen Banner's sterling silver pieces are made using historic silversmithing techniques. Sheets of silver are cut and hammered into shape, heated, cooled quickly in water, and hammered again. Collections include: Renwick Gallery, Smithsonian Institution, Washington, DC; Art Institute of Chicago, IL; Peabody Essex Museum, Salem, MA; Mint Museum of Craft + Design, Charlotte, NC. ■ PAGE 86.

■BRIAN BAXTER & MARKIAN OLYNYK

Brian Baxter and Markian Olynyk are site-specific glass artists with a versatile, innovative team approach. They have installed their windows, walls, murals, sculpture, screens and skylights worldwide. Collections include: Vancouver International Airport; World Trade Center; Bank of Hong Kong; Calgary Olympic Speed Skating Oval. ■ PAGE 40.

■ROSS PALMER BEECHER

The graphics covering discarded soda and tin cans catch the interest of Ross Palmer Beecher, who "quilts" pieces of these cans together. For her, this process is a way of recycling while reinventing the use of everyday objects. Collections include: Microsoft, Redmond, WA; Seattle Art Museum, WA; Tacoma Art Museum, WA. ■ PAGE 157.

■FRED BENDHEIM

Working within a variety of media, from acrylic to watercolor, Fred Bendheim creates calm, stylized paintings with deeply felt, though quietly composed, subject matter To achieve these effects, he incorporates a number of techniques — brushing, dipping, sponging, spraying and collage. Collections include: Ritz-Carlton Hotel, San Juan, Puerto Rico; The Paradise Peak Corporation, Scottsdale, AZ. ■ PAGE 136.

■LESLIE C. BIRLESON

Leslie C. Birleson's works are internally illuminated sculptures of aluminum, polycarbonate and silk. He has created numerous large- and small-scale sculptural installations for both public and private international collections. ■ PAGE 36.

■SHARON BOARDWAY

Sharon Boardway went to art school to study printmaking and painting, but returned her focus to jewelry — which she had been creating since her childhood — after graduation. She prefers working with uncommon materials, starting with a stone or fragment that stands out, and then combining other elements to bring out the beauty in each piece. ■ PAGE 203.

■THEODORE BOX

Theodore Box's art is in private collections the world over. Each piece of art furniture is designed to accommodate climactic variations without losing its precise functional properties. ■ PAGE 71.

■LATCHEZAR BOYADJIEV

Latchezar Boyadjiev is a graduate of the Academy of Applied Arts in Prague, Czech Republic, with training in sculptural glass. By using cast-glass techniques, he explores abstracting color, light and form. Boyadjiev's works are in museum and private collections around the world. ■ PAGE 207.

■ANN BROOKS

When creating her jewelry, Ann Brooks knits nylon-coated copper wire on a standard knitting machine to produce a basic fiber material. She then cuts, sculpts, sews, joins and sometimes beads the individual elements of each piece, using her hands to sculpt hard metal into soft jewelry. ■ PAGE 30.

■SHELLIE BROOKS

Shellie Brooks' work is created with precious metal clay: fine particles of silver suspended in a matrix of water and an organic binder into which Brooks carves and stamps designs. The clay completely burns away when fired, leaving a pure silver form. ■ PAGE 56.

■BOB BROWN

Bob Brown's paintings are thickly textured with acrylic paint applied with a palette knife. His subjects are representational and mostly landscapes. His paintings have been exhibited in galleries and public spaces in the United States, Monoco and France. ■ PAGE 140.

■SUSAN SILVER BROWN

Susan Silver Brown transfers her interests in philosophy and the subconscious into her chased and repoussé work. As she incorporates such elements as glass, shell or gemstone, and details the surfaces with photo-etching, her pieces take on mystical qualities that transcend place and time. Collections include: Tucson Museum of Art, AZ. ■ PAGE 56.

■LAURA MILITZER BRYANT

Laura Militzer Bryant's weavings are abstract paintings constructed line by line. She colors each line herself — dyeing and painting directly onto the white threads. Collections include: Xerox Corporation, Rochester, NY; Mobil Oil Corporation; Eli Lilly Corporation; St. Vincent Hospital, Indianapolis, IN; Metropolitan Life, Indianapolis, IN. ■ PAGE 198.

■JAN BUCKMAN

Jan Buckman's baskets grow from sketches that are refined into patterns drawn out on graph paper. Having a clear mathematical understanding of how the pattern will change once it takes form in three dimensions is crucial. Collections include: Minneapolis Institute of Art, MN; Wustum Museum of Fine Art, Racine, WI; Erie Art Museum, PA. ■ PAGE 105.

■BARBARA BUER

Barbara Buer paints in both watercolors and oils — two mediums so completely different that she sometimes wonders how she can love them equally. Collections include: Hilton Hotels Corporation, Harrisburg, PA; Hershey Foods Corporation, Hershey, PA; Keystone Financial Services, Harrisburg, PA; Farmers Trust Company, Carlisle, PA. ■ PAGE 15.

GARY BUKOVNIK

Gary Bukovnik primarily uses watercolors, monotypes and lithographs for his artwork, creating floral images of great depth and intensity. Collections include: The Smithsonian Institution, Washington, DC; Metropolitan Museum of Art, New York, NY; Brooklyn Museum, NY; Fine Arts Museum, San Francisco, CA; Bank of America. ■ PAGE 201.

CATHLEEN BUNT

Through many years of study and practice, Cathleen Bunt has become a fountainhead of jewelry innovation. Incorporating gems, pearls and gold in proportional and balanced pieces, she organizes elements as a painter orders a composition. ■ PAGE 58.

CHRISTIAN BURCHARD

Christian Burchard turns his baskets when the wood is extremely wet, exploiting the wood's flexibility and allowing for the creation of exceptionally thin pieces. The baskets are allowed to dry freely, warping into whatever final shape they please. Collections include: Royal Cultural Center, Jedda, Saudi Arabia; Renwick Gallery, Smithsonian Institution, Washington, DC. ■ PAGE 182.

ELLIE BURKE

Ellie Burke works each glass piece over a flame, holding it in her hands. Because flameworked glass can be reheated more easily than other forms of hot glass, she can make many components ahead of time, assembling them in the flame to create a more elaborate piece. Collections include: Rockford Art Museum, IL. ■ PAGE 177.

CLAY BURNETTE

For basketmaker Clay Burnette, the creation of a pine needle basket is a painstakingly slow process. Burnette gathers each longleaf pine needle directly from the tree, dries it, dyes it, paints it and soaks it before even beginning the coiling process. When the basket is complete, it is heat treated with a mixture of beeswax and paraffin. ■ PAGE 47.

BARBARA BUTLER

Barbara Butler builds her furniture to fit its natural function, to be a simple but well-made canvas for her carving and staining. With their wooden handles, brilliant colors and sinuous carving, her pieces infuse their surroundings with warmth and light. ■ PAGE 85.

JOHN ERIC BYERS

All of John Eric Byers' work is built from solid mahogany and finished with milk paint. Each square, diamond or circle within a particular surface pattern must be painted individually. Collections include: American Craft Museum, New York, NY. ■ PAGE 101.

JUDITH B. CARDUCCI

Pastels are Judith B. Carducci's medium of choice because of their richness and depth of color, immediacy and permanence. Collections include: Ohio Education Association, Columbus; Hudson Library and Historical Society, OH; Hudson Chamber of Commerce, OH. ■ PAGE 117.

BARRY ROAL CARLSEN

Barry Roal Carlsen's works in oil are characterized by luminous surfaces that reflect a deep attention to light. Framed in handmade designs crafted by the artist himself, each painting is an homage to place and memory. Collections include: Rayovac Corporation, Madison, WI; Progressive Corporation, Cleveland, OH; Lathrop & Clark S.C., Madison, WI. ■ PAGE 149.

JAMES CARTER

James Carter chooses to work in gold and precious stones. His world travels directly influence his work, especially the three years he spent in the Merchant Marine. His pieces make definite industrial and nautical references, with many rivets and strong lines. Collections include: Evansville Museum of Arts & Sciences, IN. ■ PAGE 181.

WARREN CARTHER

Warren Carther works with glass at a large scale — sculpturally and within the architectural environment — producing unique work that crosses the boundaries between art and architecture, two dimensions and three. Innovative techniques in structure, abrasive blast carving and color application distinguish his work. ■ PAGE 41.

GERRY CHASE

Gerry Chase works in a collage-like style. Her process typically involves preparing fabrics, piecing them into a quilt top, painting this as if it were a canvas, and then finishing it like a "normal" quilt. Collections include: Brackensick Quilt Collection, Los Angeles, CA; Kaiser Foundation Hospital, Vallejo, CA. ■ PAGE 130.

AMY CHENG

Amy Cheng has developed a painting vocabulary based in various cultures. Her oil works often rely on repeated pattern, brilliant color and an intricate layering of space. Her most recent works, while abstract, still provide visual references to planets and stars, fabrics and maps. ■ PAGE 109.

J. AGNES CHWAE

J. Agnes Chwae forms her bowls from single discs of metal, hammering them over steel forms and compressing their walls into the right shape. Concentric rings that form after a rock breaks the surface of water are translated into a bowl lipped with multiple rims, while running water is represented by piercing the wall of a vessel. Eccentric shapes play with the idea of a pot, but always just barely stop short of violating it. ■ PAGE 80.

■ THOMAS CLARKSON

Thomas Clarkson's pieces begin as shapes thrown on the wheel. They are then altered, augmented, pressed and stretched. His finished pieces capture the plastic, fluid nature of wet clay. Collections include: Mint Museum of Craft + Design, Charlotte, NC; Canton Art Institute, OH. ■ PAGE 80.

■ JEREMY R. CLINE

Taking cues from antiquity as well as contemporary sources, Jeremy R. Cline crafts each piece as part of his ongoing examination of the vessel as an art form. His work in glass reflects the versatility of his craftsmanship. ■ FRONT COVER.

■ STUART COFFEE

Each of Stuart Coffee's original designs begins as a sketch that is carved into a model. He then creates the actual pieces, commonly using lost-wax and hand-fabrication techniques. Many pieces incorporate unusual devices such as gold screws, rivets and rubber fasteners, making each unique. ■ PAGE 168.

■ TIMOTHY COLEMAN

Timothy Coleman defines his furniture with richly textured surfaces and gracefully balanced forms. Using low-relief carving and thick veneer tiles, he customizes each piece with a variety of decorative effects. ■ PAGE 93.

■ PETER COLOMBO

Peter Colombo uses glass, handmade ceramic tile and natural stone to create site-specific mosaics in both public and private environments. His studio offers original or collaborative designs, fabrications from artwork and on-site installations. ■ PAGE 38.

■ GWENN CONNOLLY

Indoors or outdoors, in a public place or private corner, Gwenn Connolly's works resonate with the viewer's spirit. Her bronzed sculptures are suitable for a range of environments, including heath care facilities, corporate settings, resorts, residences and gardens. ■ PAGE 66.

■ JEANNE CONTE

Jeanne Conte's subjects range from children, dancers and body-builders to landscapes, nudes and flowers. She is fascinated by how different the world looks through a lens and how perspective can give objects a whole new reality. All of her prints are done by hand in silver gelatin on fiber paper. ■ PAGE 129.

■ CYNTHIA CORBIN

Cynthia Corbin dyes and paints her own fabrics in a playful process that reminds her of the experience of painting as a child. In contrast, she finds the quilting process painstakingly slow, as she waits for the right fabric, stitching, colors and images to show themselves to her. ■ PAGE 191.

■ ANTHONY CORRADETTI

Anthony Corradetti produces dense, overlapping patterns and colors by using glass luster paint on the surface of blown vessels. Each layer must be fused in an annealing oven individually, and he uses as many as 12 firings to finish each piece. Collections include: White House Collection of American Crafts, Washington, DC; Renwick Gallery, Smithsonian Institution, Washington, DC. ■ PAGE 206.

■ STEPHAN J. COX

After his blown-glass forms cool, Stephan J. Cox shapes them with diamond sawing, high-pressure sand carving, wheel grinding, belt grinding and diamond-point carving techniques. Collections include: Corning Museum of Glass, NY; White House Ornament Collection, Washington, DC. ■ PAGE 44.

■ BARBARA CRANE

Barbara Crane has worked with all photographic formats and materials, from platinum prints to large-scale, one-of-a-kind Polaroids. Collections include: Museum of Modern Art, New York, NY; Renwick Gallery, Smithsonian Institution, Washington, DC; Getty Museum, Malibu, CA; Bibliothéque Nationale, Paris, France; National Museum of Modern Art, Kyoto, Japan. ■ PAGE 48.

■ MICHAEL CREED

Michael Creed's furniture expresses his broad and varied approach to object making. His use of materials attests to this: with such fine, traditional elements as beautiful woods, and such everyday supplies as paper bags, he invests each piece with an imaginative mix of detail and humor. ■ PAGE 84.

■ ANYA CRISTINA

Anya Cristina's subjects include architecture, landscapes, nature and people, and she uses her camera as a tool for introspection and explanation. She waits patiently for the perfect light to illuminate her subject; photographs that "create an uncensored visual image" reward her extraordinary patience. ■ PAGE 128.

■ BRENT CROTHERS

To form each sculpture, Brent Crothers cuts, rips and chisels a rough block of wood — using "whatever it takes" to get his material to speak with a clear voice. Collections include: Delaware Art Museum, Wilmington, DE. ■ PAGE 194.

■ ROBERT DANE

Robert Dane's work revolves around the themes of life and growth. He manipulates glass into sculptural forms with a variety of techniques, including blowing and hot-working solid glass. Collections include: American Craft Museum, New York, NY; Philadelphia Museum of Art, PA; Corning Museum of Glass, NY; Glasmuseum, Ebeltoft, Denmark. ■ PAGE 164.

■ JACLYN DAVIDSON

Jaclyn Davidson is one of the few contemporary jewelers using the ancient basse-taille technique of creating enameled gold jewelry. With the aid of a magnifying glass, she carves her finely detailed bracelets, rings and pendants in wax and casts them in 18K gold. The entire surface is then enameled, creating colors of varying depths in the design. ■ PAGE 156.

■ JAMIE DAVIS

Trained as a potter, Jamie Davis has spent the past 10 years working with mixed media. His current wall pieces incorporate an improvisational approach, relying on layers of material and technique to build an object somewhere between drawing and sculpture. Collections include: High Museum of Art, Atlanta, GA; Columbia Art Museum, SC. ■ PAGE 31.

■ MARY DICKEY & MARTHA GLOWACKI

Mary Dickey and Martha Glowacki's pieces are hand cast in bronze. They use only the most durable outdoor woods, such as reclaimed tidewater red cypress and ironwoods. Every step in the process is executed with function and fine design in mind — from carving a foundry pattern and making a sand mold to grinding down the rough spots. ■ PAGE 200.

■ DAVID D'IMPERIO

David D'Imperio's designs are constructed from a combination of wood, stainless steel, Bakelite plastic and a heat-resistant polycarbonate film. They begin sculpturally, with an emphasis on form, and end with an illuminating functionality. ■ PAGE 87.

■ SUSAN DUNSHEE

Susan Dunshee creates fiber pieces using an original technique of machine-stitching dyed yarns and fabric shreds between layers of nylon netting. This allows her to produce rich textures, complex colors and great depth. Collections include: Hyatt Corporation; American Express Corporation; HBO Corporation. ■ PAGE 54.

■ DENNIS ELLIOTT

Dennis Elliott's artistry begins with his lathe-turned forms and continues as he uses a combination of carving, sanding and grinding to bring out the natural beauty of the wood. Collections include: Renwick Gallery, National Smithsonian Institution, Washington, DC; American Craft Museum, New York, NY; Museum of Fine Arts, Boston, MA. ■ PAGE 26.

■ ROBERT W. ELLISON

Robert W. Ellison creates large, whimsical sculptures in rich colors using steel, concrete, neon and clockworks. His in-house fabrication facility offers excellent value and craftsmanship. Collections include: Municipality of Anchorage, AK; University of Wisconsin-Platteville, WI; Di Rosa Preserve, Napa, CA; Washington State University, Pullman, WA. ■ PAGE 60.

■ STUART ELSTER

Stuart Elster's paintings draw attention to the fact that the way we look at the past changes continually to adapt to our understanding of the present. His works are energetically composed in a sophisticated palette of confident brushstrokes. ■ PAGE 99.

■ THEODORA ELSTON

Each of Theodora Elston's pieces begins as a pencil drawing on paper. For her tapestries, she paints a small to-scale watercolor study to use as a color and design reference and then weaves her work on a 40" floor loom. ■ PAGE 145.

■ COURTNEY FAIR

Courtney Fair uses unseasoned white oak from a local sawmill, working the material with hand tools and steam-bending techniques to create unique objects that evoke the familiar. ■ PAGE 73.

■ VASILY FEDOROUK

Having mastered work techniques for stone, bronze and wood, Vasily Fedorouk synthesizes sculptural elements in architecture, adopting either a realistic or abstract interpretation. His work is represented in museum collections in Russia and Ukraine, as well as private collections around the world. ■ PAGE 184.

■ GARY FEY

To distinguish himself from other batik artists, Gary Fey keeps his silk stretched throughout the process of dyeing, washing and waxing. By rinsing the fabric with the silk still attached to the stretcher, he keeps the batik crackle-free. Collections include: Ghost Ranch Conference Center, Abiquiu, NM; Aaron Spelling Productions, Los Angeles, CA; Oscar de la Renta, New York, NY. ■ PAGE 94.

■ RON FLEMING

Ron Fleming gathers exotic wood from all over the world. He shapes his turned forms with chisels and power carving tools and finishes each piece with several coats of lacquer, hand rubbed to a sheen. Collections include: White House Collection of American Crafts, Washington, DC; Mint Museum of Craft + Design, Charlotte, NC; Los Angeles County Museum of Art, CA. ■ PAGE 62.

■ DAVID FOBES

David Fobes' painted wood furniture explores surface treatments that confound the viewer's perception. His tables and cabinets are juggling acts of utility, metaphor, illusion and form that challenge the viewer's ability to distinguish the difference between the physical world and metaphysical experience. ■ PAGE 100.

■JOANNE FOX
Joanne Fox came to bookmaking as she made the relationship between word and object more intimate. Writing on the surface of sculptures evolved into writing within them, and she developed a new invention: the "sculptured book." Each piece is a collage of techniques and materials — a blend of feathers, branches and bones, of metalsmithing, bookbinding and painting. ■ PAGE 120.

■RON GALLMEIER
Ron Gallmeier uses a number of innovative processes to produce photographic prints that are far more stable and resistant to ultraviolet light than those developed with more traditional materials. His images of natural settings are admired and collected internationally. ■ PAGE 134.

■CAT GLAZER & KEITH LAMBERTSON
In their granulated jewelry, Keith Lambertson and Cat Glazer draw on the traditions of the ancient Etruscans and Greeks, arranging hundreds of tiny gold balls into intricate patterns without the use of solder. ■ PAGE 57.

■JENNA GOLDBERG
Jenna Goldberg uses two primary techniques to create a collage effect in her work: an intaglio-like surface carving in which designs are carved through the painted surface, allowing the light maple wood to shine through; and Xerox transfer, a process in which images are transferred onto wood or painted surfaces. ■ PAGE 171.

■PAUL CARY GOLDBERG
Using familiar objects and relating color, texture, form and space through light and the absence of light, Paul Cary Goldberg creates visual images with emotional depth and beauty. His finished work is produced as iris prints, with each image limited to an edition of 15. ■ PAGE 7.

■OWEN GRAY
The lush environment of the Everglades and Owen Gray's own sense of the tropical world — its fantasies, shadows, sunbeams and dense vegetation — have inspired his richly painted, complex landscape compositions. ■ PAGE 152.

■DON GREEN
Don Green works with domestic and imported hardwoods and veneers, old-fashioned milk paint, steel and brass. Incorporating bold contemporary lines and colors with the elegance of traditional forms, he has created a distinct style without sacrificing utility. ■ PAGE 68.

■ANNA GUZEK
Anna Guzek's serving pieces are constructed primarily of acid-etched sterling silver of varying surface textures and lengths; some feature anodized aluminum and niobium. Each piece within the collection is entirely hand-wrought. ■ PAGE 88.

■CHAD ALICE HAGEN
Chad Alice Hagen colors wool with traditional resist dyeing methods from Japan, India and Africa and then folds, wraps and hand stitches the felt pieces together. Each work consists of hundreds — sometimes thousands — of individual fragments of felt. Collections include: Mint Museum of Craft + Design, Charlotte, NC; Minneapolis Institute of Art, MN. ■ PAGE 37.

■WALTER HAMADY
Walter Hamady's collages, books and small sculptures comprise an array of techniques, materials and ideas — they can be printed, cut, torn, sewn, stamped, perforated, grommeted, pinched or bitten. Collections include: Victoria and Albert Museum, London, UK; Whitney Museum of Art, New York, NY; National Gallery of Art, Washington, DC. ■ PAGE 120.

■TIM HARDING
Tim Harding's pieces, comprised of cut, layered and stitched bits of silk, have a pixel-like quality reminiscent of pointillism. He uses multiple solid colors in tight proximity to create the kind of vibrant richness associated with the Impressionists. Collections include: American Craft Museum, New York, NY; U.S. Embassy, Bangkok, Thailand. ■ PAGE 162.

■WILLIAM HARSH
William Harsh's subject is the common, essential stuff arrayed in a painter's studio: easels, canvases, tables, stools, a ladder, paint tubes, brushes. As he alters, recombines, and drags around forms in accordance with his feeling for the developing construction, the resulting ensembles are sometimes spare, sometimes jammed and clotted. ■ PAGE 65.

■PATTY HAWKINS
Patty Hawkins' techniques include free-cut curved piecing, inlay piecing and direct appliqué. She works with her own hand-dyed fabrics, adding an occasional spark with pre-dyed fabrics for graphic effects. Collections include: Kaiser Permanente, Denver, CO; Full Deck Project, Los Angeles, CA. ■ PAGE 190.

■YOSHI HAYASHI
Yoshi Hayashi was born in Japan, where he grew up watching and learning the rigorous techniques of Japanese lacquer art from his father. He has made the technique his own by using oil paints, resin varnishes, bronzing powders, and metallic leaf in place of the traditional Japanese lacquer. ■ PAGE 136.

■ DAVID CALVIN HEAPS
David Calvin Heaps is committed to producing museum-quality, functional art. Formed in clay, each of his designs bears his signature form and surface language — a calm balance between smooth lines and irregular shape. ■ PAGE 12.

■ ALLEN HESS
Allen Hess uses large-format cameras to capture the rich tonalities and wealth of detail in natural and industrial landscapes. Collections include: Metropolitan Museum of Art, New York, NY; National Museum of American Art, Washington, DC; Museum of Fine Arts, Boston, MA. ■ PAGE 138.

■ BILL HIO
Bill Hio, a retired priest of the Episcopal Church, began designing materials after starting a craft center for poor war widows in Okinawa. He came to his present art form, "grosse pointe," while developing wall hangings and banners for the interior of the church where he was serving. In retirement, his hobby has become a vocation. ■ PAGE 151.

■ JERI HOLLISTER
Jeri Hollister's sculptures begin with long, hollow, extruded shapes and wheel-thrown forms. She then cuts, tears and reassembles the thrown and extruded parts to form various portions of the sculpture. The parts are assembled and glued after the clay has been glazed and twice fired. Collections include: Marriott Corporation, Cleveland, OH; Ford Motor Company, Colorado Springs, CO. ■ PAGE 147.

■ ANDREW HOLMES
While in school, Andrew Holmes found he could get almost any materials he wanted for his work from the demolition men who were knocking down Victorian houses in the area. To this day, he still uses old timber, broken tiles and rusty metal to build his furniture and assemblages. Collections include: Stoke on Trent City Museum and Art Gallery, UK; Birmingham Museum and Art Gallery, UK. ■ PAGE 34.

■ ROBYN HORN
Robyn Horn works in wood because it is the best medium to get the forms she is looking for. She uses a subtractive process, which enables her to find surprises in the wood that hide under the layers. Collections include: Renwick Gallery, National Smithsonian Institution, Washington, DC; White House Collection of American Craft, Washington, DC. ■ PAGE 23.

■ LINDA HUEY
Fascinated by clay's potential to express the forces of the natural world, Linda Huey collects leaves, sticks, flowers and seed pods for her ceramic shapes. Collections include: International Museum of Ceramic Art, Alfred, NY; Fidelity Investments, Smithfield, RI. ■ PAGE 9.

■ MARIANNE HUNTER
The images on Marianne Hunter's pieces are built up in very thin enamel layers, which are applied dry by sifting or by layering on with a tiny knife. She applies 24K gold and .999 silver foils, then coats the piece with layers of transparents. Collections include: Mint Museum of Craft + Design, Charlotte, NC; Los Angeles County Museum of Art, CA. ■ PAGES 3, 202.

■ SHUJI IKEDA
Shuji Ikeda weaves with clay. Once he realized that weaving ceramic baskets was what he wanted to do, the next step was to develop the ideal glaze. Over time he tested more than 100 and chose one to refine: he named it *Sei Shya* — "blue rust." Collections include: Unocal Corporation, Los Angeles, CA; Duke Energy Corporation, Houston, TX. ■ PAGE 178.

■ LUCY A. JAHNS
Lucy A. Jahns' work is a visual journey in color, shape and line. The appealing colors of her wall hangings lead, on closer examination, to rich surface embellishments, appliquéd shapes and stitched lines that tell a story. Collections include: Centel Corporation, Chicago, IL; Ernst & Young, Lisle, IL; Hewitt Associates, Lincolnshire, IL. ■ PAGE 144.

■ CAROLINE JASPER
Caroline Jasper begins each landscape by laying down a ground of bright red. She then applies bright white highlights, slowly adding the greens and blues of land and sky. Collections include: The City of Belair, MD; Harford County, MD; McGraw-Hill Publishers, New York, NY. ■ PAGE 16.

■ THOMAS P. KELLY
Thomas P. Kelly uses vividly colored transparent glass for his functional and sculptural artwork. His graceful and elegant forms are sometimes adorned with a twisted wrap of clear sandblasted glass. ■ PAGE 45.

■ GUY KEMPER
Guy Kemper has exhibited nationally and internationally, and his work has been featured in *The New York Times*. He strives for a design of harmonious essentials that will outlast fashion. Collections include: Jewish Hospital, Louisville, KY; Radford Acupuncture Clinic, Perthshire, Scotland; Sheikh Maktoum al-Maktoum, King of Dubai. ■ PAGE 90.

■ ELLEN MEARS KENNEDY
Ellen Mears Kennedy makes each individual piece of paper for her artwork by hand from recycled cotton and Abaca fiber from the Philippines. She then adds colorfast pigments to the pulp and forms long paper sheets with different colors on the fronts and the backs. These pieces are then cut, folded and assembled into one large image by attaching the sheets in rows to a linen backing. ■ PAGE 54.

■ BRIAN T. KERSHISNIK

Brian T. Kershisnik welcomes the influence of children, artistic greats and cave paintings in his oil-on-paper and panel works. He allows experimentation and inspiration to guide his open-ended images. Collections include: Springville Art Museum, UT; Delta Airlines; Museum of Church History and Art, Salt Lake City, UT. ■ PAGE 118.

■ ROBERT GLENN KETCHUM

Robert Glenn Ketchum was one of the first American photographers to begin shooting transparency film and printing it directly onto Cibachrome/Ilfochrome paper. Collections include: National Museum of American Art, Washington, DC; Center for Creative Photography, Tucson, AZ; Metropolitan Museum of Art, New York, NY; Museum of Modern Art, New York, NY. ■ PAGE 204.

■ BRUCE KLEIN

A *plein air* painter, Bruce Klein has been known to tie himself up in a tree where he will sit and draw for hours mesmerized by light, color and the shadows that stretch further and further across the land as day is overtaken by night. The surfaces of his paintings are characterized by a thick and translucent impasto. ■ PAGE 141.

■ LIBBY KOWALSKI

Libby Kowalski's mixed-media approach passes beyond the boundaries of traditional methods. She transforms laces, leno and devoré fabrics beyond their original appearance and intent. Collections include: The Museum of the Fashion Institute of Technology, New York, NY; IBM Corporation, Detroit, MI; Kresge Corporation, Bloomfield Hills, MI. ■ PAGE 55.

■ BUD LATVEN

The vessel forms of Bud Latven's *Segmented Bowls* series are made of exotic hardwoods and veneers. They are constructed using the process of segmentation: stack-laminating segmented rings into a constructed body and then turning them on a lathe. Collections include: National Museum of American Art, Smithsonian Institution, Washington, DC; Los Angeles County Museum of Art, CA. ■ PAGE 24.

■ R.A. LAUFER

Rick Laufer uses only locally grown hardwoods and never coats them with veneers. Every board used for his furniture is chosen with care, its grain selected to match the figure and pattern of the entire design. His designs expose the joinery of the pieces, and the simple hand-rubbed oil finish highlights the natural grain of the wood. ■ PAGE 75.

■ SUSAN LAWSON-BELL

The teacup intrigues Susan Lawson-Bell. She paints with glowing oils and metallic inks to evoke form and color, shadow and depth. Collections include: National Institutes of Health, Bethesda, MD. ■ PAGE 49.

■ NORMAN LERNER

In his small character studies, Norman Lerner searches for tactile dimension, passionate warmth and accidental discoveries. Collections include: Museum of Modern Art, New York, NY; Santa Barbara Museum of Art, CA; International Center of Photography, New York, NY. ■ PAGE 115.

■ JANICE LESSMAN-MOSS

The qualities of the woven process and its corresponding rich history of patterns and images provide a fertile point of departure for Janice Lessman-Moss, allowing her to distill the abstract properties of her mathematical and material concerns. Collections include: American Craft Museum, New York, NY; Ohio Craft Museum, Columbus, OH; Bank South, Atlanta, GA. ■ PAGE 94.

■ MARC LEUTHOLD

Sculptor Marc Leuthold makes intricately carved discs, wheels, cones and hemispheres in clay or glass. Each piece is unique and labor-intensive. Collections include: Metropolitan Museum of Art, New York, NY; Brooklyn Museum of Art, NY; Everson Museum of Art, Syracuse, NY; American Craft Museum, New York, NY. ■ PAGE 189.

■ LINDA M. LEVIN

Linda M. Levin has been using hand-dyed fabrics for years, captivated by the exploration of textile dyes and paints. Recently she has been working with transfer dyes on sheer and opaque materials, layering them to create subtle changes in color. Collections include: Boston Consulting Group, MA; Palmer and Dodge Attorneys, Boston, MA. ■ PAGE 151.

■ NORMA LEWIS

Norma Lewis is a painter and a sculptor, with work including both pedestal and monumental bronzes. Her sculptures embody integrity of material, grace of weight and simplicity of form. Her works are in the homes and gardens of many private collectors. ■ PAGE 187.

■ IVO LILL

Ivo Lill works with cold technologies to create his intricate glass sculptures. By cutting, etching, gluing, grinding, polishing and sandblasting, he is able to turn basic pieces of glass into elegant and refined works of art. Collections include: Talinn Museum of Applied Art, Talinn, Estonia; The Corning Museum of Glass, NY; Ebeltoft Glass Museum, Denmark. ■ PAGE 107.

■ MARVIN LIPOFSKY

Marvin Lipofsky has created sculptural blown glass for more than 30 years, often working as a guest artist in factories and workshops overseas. His work is characterized by dramatic combinations of color and form and is included in the permanent collection of more than 50 major museums in the United States, Europe and Asia. ■ PAGE 64.

■ KARI LØNNING

To convey a sense of weight and solidity — both actual and implied — Kari Lønning uses a double-walled construction technique and frequently weaves the top edge back in toward the center. Collections include: Renwick Gallery, Smithsonian Institution, Washington, DC; White House Collection of American Crafts, Washington, DC. ■ PAGE 175.

■ ANNE LOPEZ

With patterns and detail, Anne Lopez attempts to capture her audience in a state of unself-consciousness, a state of pleasant contemplation. Collections include: Beaumont Hospital, Birmingham, MI. ■ PAGE 154.

■ DANIEL MACK

Daniel Mack's creations are interpretations of traditional furniture styles. He uses natural forms and hardware from his collection to produce works that are both a caricature and a statement about time, history, impermanence, symmetry and accident. Collections include: Cooper Hewitt Museum of Design, New York, NY; American Craft Museum, New York, NY. ■ PAGE 35.

■ JOHN MAGGIOTTO

John Maggiotto collects images from television and art books, and marble from a quarry near his home. Then he combines the two by painting a photosensitive emulsion onto the marble, which allows a print to be made directly on the hard stone. The finished work is textural and painterly, explorative and meditative. Collections include: Center for Creative Photography, Tucson, AZ. ■ PAGE 114.

■ WILLIAM MAHAN

William Mahan's paintings represent his interest in large landscape formats, places and events, historical tributes and personal references. Collections include: Loeb and Loeb, Los Angeles, CA; Atlantic Richfield Corporation, Denver, CO; Aerojet General Corporation, La Jolla, CA; Security Pacific National Bank, Los Angeles, CA; IBM Inc., Los Angeles, CA. ■ PAGE 10.

■ THOMAS MANN

Thomas Mann works with a variety of metals, thinking of them as painters think of their palettes. He incorporates parts from electronic instruments, costume jewelry, old postcards and photos into his work, giving each piece a storytelling quality and theatricality. Collections include: American Craft Museum, New York, NY; Wustum Museum of Fine Art, Racine, WI. ■ PAGE 89.

■ MARTHA MARGULIS

Martha Margulis' primarily abstract paintings work on a number of levels. As a result of varying juxtapositions, bold primary colors mix with contrasting and complementary tones while textured and collaged surfaces play against more simplified and thinned areas of the painting. Collections include: Smithsonian Collection, Washington, DC; Everson Museum of Art, Syracuse, NY. ■ PAGE 151.

■ RICHARD MARQUIS

In the early 1970s, Richard Marquis spent a year at the famous Venini factory in Italy, learning traditional Venetian glass blowing techniques. The fine filigree and lace patterning characteristic of Venetian glass still characterize his work, which is otherwise thoroughly modern — and highly prized by collectors worldwide. ■ PAGE 111.

■ MARIE MASON

Marie Mason works with acrylic paint on canvas and paper. Although the subject matter of her paintings varies, they usually involve a figure and flowers, whose color and complexity symbolize the delicate perfection of the natural order. ■ PAGE 116.

■ BARRY MASTELLER

With a landscape as a reference, Barry Masteller paints multiple layers, achieving a potent luminosity. His work has been featured in many museum and gallery exhibitions and is included in museum, private and corporate collections around the world. ■ PAGE 18.

■ WENDY MATTSON

Wendy Mattson captures those occasions when light, color and shadow converge to transcend form — moments in childhood as raucous as secret laughter between friends and as sweet as the taste of ice cream on a summer afternoon. Collections include: Western Water Products, Inc., El Dorado, CA; Prairie Gardens, Inc., Champaign, IL. ■ PAGE 122.

■ MICHAEL MCAREAVY

A self-taught photographer, Michael McAreavy works solely with the Cibachrome printing process for its brilliant color saturation and high image sharpness. His work seeks to present an emotionally charged scenic landscape. Collections include: Johnson and Johnson, New Brunswick, NJ; Opel Bank, Leipzig, Germany. ■ PAGE 148.

■ DONNA MCGINNIS

Donna McGinnis works with a wide range of two-dimensional media. From pencils to pastels, acrylics to oils, she relishes the processes of creation fostered by the use of varied techniques and tools. Collections include: The Arkansas Art Center, Little Rock; Lucasfilm, Los Angeles, CA; Royal Lokilani, Hawaii, HI; Transamerica Corporation, San Francisco, CA. ■ PAGE 20.

■ **STEVEN MCGOVNEY & TAMMY CAMAROT**
Steven McGovney designs and slip casts each piece in low-fire white clay, hand finishing it with pulled spouts, handles and sculptural additions. After the first firing, Tammy Camarot gains control, painting underglaze colors and delicately scribing highlights. Fired again, the pieces are dipped in clear glaze and sent to the kiln one last time. ■ PAGE 14.

■ **JANICE MEHLMAN**
Janice Mehlman works with long-time exposures, allowing the light to reach its maximum vitalizing value, animating her subject and creating a photographic print of heightened intensity. Collections include: Bibliothèque Nationale, Paris, France; Brooklyn Museum of Art, NY; IBM Corporation, Westchester, NY; Musée Nicephore Niepce, Chalon-sur-Saone, France. ■ PAGE 32.

■ **GEORGE THOMAS MENDEL**
George Thomas Mendel documents beautiful moments that most people overlook. Whether presenting waterscapes, florals, architecture or portraits, each of his photographs reveals a glimpse of his artistic viewpoint. All of his work is printed using traditional processes and materials that trace back to the beginnings of photography. ■ PAGE 33.

■ **MARIO MESSINA**
Mario Messina sees the creation of furniture as an opportunity to explore the union of function and art. Working with a broad assortment of materials — highly figured woods, stone, glass and metals — and using such techniques as tapered lamination, carving and inlay (as well as traditional joinery), he weaves a coherent vision into reality to create finely crafted furniture of distinction and value. ■ PAGE 72.

■ **SALLY METCALF**
Sally Metcalf begins most of her baskets with a plaited square base. Each warp is made of three separate pieces of reed to allow for more flexibility in weft interaction later on. All of her baskets are made of stitched and planed rattan reed, either left in their natural color or dyed with lightfast, colorfast, fiber-reactive dyes. ■ PAGE 76.

■ **DIMITRI MICHAELIDES**
Dimitri Michaelides' brightly colored opaque vessels are made from individually crafted glass elements — birds, handles, polka dots and flames — attached to the blown form with a small bit of hot clear glass. Though each shape is reminiscent of an ancient vessel, it is transformed with striking colors to secure its place in the modern age. ■ PAGE 169.

■ **ROGER MINICK**
Roger Minick builds each series of photographs around the distinct character of a given place, shedding light on the often-buried history, culture and politics of the people and land. Collections include: J. Paul Getty Museum, Los Angeles, CA; Los Angeles County Museum of Art, CA; Metropolitan Museum of Art, New York, NY; Renwick Gallery, National Smithsonian Institution, Washington, DC. ■ PAGE 133.

■ **BRUCE MITCHELL**
Bruce Mitchell prefers working with green wood, because it is easier to remove excess material when the wood is wet and elastic. To create his works, he sculpts and carves with chainsaws, lathes and power-carving and sanding tools. Collections include: Renwick Gallery, National Smithsonian Institution, Washington, DC; High Museum of Art, Atlanta, GA; Oakland Museum of Art, CA. ■ PAGE 63.

■ **HOLLY ANNE MITCHELL**
Holly Anne Mitchell's jewelry and accessories have elevated old newsprint to a medium for personal adornment — it is rich in color, texture and form as well as the perfect marriage between creativity and recycling. She likes the bright colors, typefaces and interesting textures she can achieve using it in her creations. ■ PAGE 174.

■ **WILLIAM MORRIS**
The glass sculptures of William Morris express his fascination with animal forms and primitive cultures. He is one of the most prolific and admired of contemporary glass artists. Collections include: Metropolitan Museum of Art, New York, NY; Louvre, Paris, France; Victoria and Albert Museum, London, UK. ■ PAGE 183.

■ **EDIE MORTON**
Poetic, ethereal and organic qualities are found in Edie Morton's light diffusion sculpture and luminaires. In her transformation of various woods, porcelain, gold and silver leaf, Japanese papers and fabrics, one may experience the interconnectedness of all life. ■ PAGE 77.

■ **M.L. MOSEMAN**
M.L. Moseman's paintings focus on rural farm scenes. Using simplified compositions with strong light and color, he captures the ephemeral nature of agrarians at one with the land. Collections include: Sioux City Art Museum, IA; Kansas State Historical Society, KS. ■ PAGE 4.

■ **MARTIN MUGAR**
Martin Mugar strives to engage the viewer in a search toward meaning. His large-scale oil paintings shatter existing planes with explosions of perfect rings within fluid washes, creating a tone of celebration. Collections include: Boston Public Library, MA; Fuller Museum, Brockton, MA; Sogen International, New York, NY; Museum of Modern Art, Armenia. ■ PAGE 155.

■ CHARLES MUNCH

Charles Munch uses an artistic language of symbols that point to meaning and can be manipulated like letters. As a painter, he works to tease new meanings out of supposedly familiar things. Collections include: Dain Rauscher, Inc., Minneapolis, MN; Heritage Insurance Company, Sheboygan, WI. ■ PAGE 52.

■ KATHLEEN NARTUHI

Kathleen Nartuhi's pieces are inspired by the aesthetics of Japanese ceramics and Chinese bronze vessels of the Shang dynasty. Thrown on the wheel or built by hand, her porcelain vessels are embellished with distinctive feet, unique handles and an occasional sgraffito motif. Collections include: Israeli Embassy, Washington, DC. ■ PAGE 81.

■ TOM NEUGEBAUER

Whether reflecting on the soaring and arching monuments of human imagination or noting the power and beauty of the earth, sea and sky, Tom Neugebauer balances his sculptures with a combination of media, ordering experience with a mixture of steel, copper, wood, stone and clay. Collections include: Bankers Trust, New York, NY; Delta Airlines, Atlanta, GA; Lannan Foundation, FL. ■ PAGE 59.

■ LAURA FOSTER NICHOLSON

Textile artist Laura Foster Nicholson studied weaving at the Cranbrook Academy of Art. She enjoys working with domestic subjects to make even the most ordinary contents of a vegetable garden, pantry or tool shed into appealing works of art. Collections include: Cooper-Hewitt National Design Museum; The Minneapolis Institute of Arts, MN; Archives of the Venice Biennale, Venice, Italy. ■ PAGE 165.

■ BRUCE A. NIEMI

Harmony, balance and energy are illuminated in the stainless steel and silicon bronze abstract freeform sculptures Bruce A. Niemi creates. The sizes of his sculptures and wall reliefs range from small-scale to large-scale public work. ■ PAGE 61.

■ NANCY EGOL NIKKAL

Nancy Egol Nikkal creates collages, paintings and prints with textured, layered surfaces and a sophisticated color palette that includes muted earthtone greens, beiges and smokey mauve grays, as well as subtle to vibrant reds, blues, yellows, rusts and browns. She exhibits nationally and internationally. ■ PAGE 51.

■ CRAIG NUTT

Much of Craig Nutt's work is rooted in the garden — vegetables have provided him with a visually and metaphorically rich and evocative vocabulary. Collections include: Renwick Gallery, Smithsonian Institution, Washington, DC; High Museum of Art, Atlanta, GA; Birmingham Museum of Art, AL; Mobile Museum of Art, GA; Huntsville Museum of Art, AL. ■ PAGE 29.

■ JEANNE O'CONNOR

Jeanne O'Connor takes a black-and-white photographic transparency, paints color on the back of the image, and places this over a layer of pastel or collage elements, combining the documentary quality of the photograph with the sensuous beauty of paint and collage. Collections include: Bibliothèque Nationale, Paris, France; Brooklyn Museum of Art, NY. ■ PAGE 19.

■ VINCENT LEON OLMSTED

Pouring molten glass into a sand mold, Vincent Leon Olmsted contrasts the natural seductiveness of polished glass with the rough surface of cast glass. A found object housed within each of his works serves as the starting point of his narrative, luring the viewer into the chronicle of each piece. Collections include: Rhone-Poulenc Rorer, Inc., Collegeville, PA; Bonita Granite, Mullica Hill, NJ. ■ PAGE 160.

■ ROBIN PALANKER

Working entirely with her hands, Robin Palanker creates depth with thick layers of brilliant colors. With pastel on paper she creates velocity and a luminous glow. Using dancers and acrobats as moving models, she sets agitated movement against an already uneasy stasis. ■ PAGE 127.

■ KRIS PATZLAFF

Kris Patzlaff's embossed silver jewelry is created through a process much like intaglio printmaking: placing resist on metal plates, drawing and etching to expose the metal, and then pressing silver into the exposed areas. Balancing this meticulous technique, the drawing itself relies on automatic writing — a personal language that is spontaneous, never predetermined. ■ PAGE 102.

■ RONALD HAYES PEARSON

During his lifetime, Ronald Hayes Pearson developed a classic and timeless body of work. The hammer was his primary tool for shaping malleable gold and silver pieces. Their simple, complex and fluid forms remain exciting and appealing. Collections include: Smithsonian Institution, Washington, DC; American Craft Museum, New York, NY; Museum of Modern Art, New York, NY. ■ PAGE 186.

■ KAREN PERRINE

Karen Perrine begins with white fabric and adds color through dyeing techniques such as immersion, dipping, direct application and stamping. Some of her quilts are formed from pieced and painted cotton fabrics. Others are whole cloth, with the entire design painted on one piece of yardage. Collections include: Yoshizawa Hospital, Tokyo; City Hall, Kirkland, WA. ■ PAGE 153.

■ LINDA S. PERRY

Linda S. Perry designs the surfaces of much of her fabric herself — hand-dyeing, printing and marbling cottons and silks, and incorporating metallic leaf and paints. Inspired by Italian frescoes and Japanese design, she aims for a painterly effect in her quilts. Collections include: White House Ornament Collection, Washington, DC; American Embassy, Caracas, Venezuela. ■ PAGE 96.

■ JOANNE WOOD PETERS

Joanne Wood Peters has worked with various fiber arts in her lifetime, but has recently devoted her skills to basketweaving. She was originally self taught, but tries to take classes to inspire her and push her work in new directions. She has taught basketweaving for the past 10 years, and her work can be found in several galleries throughout New England and the Midwest. ■ PAGE 166.

■ DIANE PETERSEN

Diane Petersen paints the beauty found in everyday objects and Midwestern landscapes. Using impressionistic techniques, she paints evocative scenes about the significance of place. Light is brilliantly rendered in her work. Her paintings are in corporate and private collections throughout the world. ■ PAGE 123.

■ ROBERT PFUELB

Robert Pfuelb is continually searching for new and innovative techniques to create his work. Currently, his pieces are formed through a hydraulic die-forming process. His primary material is etched gold. ■ PAGE 102.

■ PETER PIEROBON

Each of Peter Pierobon's pieces are carved, sanded and finished entirely by hand. By combining contemporary styling, traditional craftsmanship and the ritualistic use of decorative elements, he produces a distinct relationship between the primitive and the sophisticated. Collections include: American Craft Museum, New York, NY; Mint Museum of Craft + Design, Charlotte, NC. ■ PAGE 15.

■ CARL POWELL

From residential stained glass projects to complete glass environments for public buildings, Carl Powell's hand-ground and polished thick, clear bevels have transformed the art of glass into a visually kinetic experience. Collections include: The International Olympic Committee; Cities of Atlanta, GA and Oakland, CA; The Clock Tower, San Francisco, CA. ■ PAGE 196.

■ JOSEPH & GEORGIA POZYCINSKI

Joseph and Georgia Pozycinski have worked as sculptors in various media since the mid-1970s, but now work exclusively in bronze. Their sculptures, many of which are fountains, are produced at their own casting and fabrication studio. Their works are in government, corporate and private collections. ■ PAGE 25.

■ JOHN PUGH

John Pugh's trompe l'oeil murals have received international attention. He has completed an array of national public art commissions for exterior and interior settings. His pieces may be painted on canvas or panels in his studio and then site-specifically integrated. ■ PAGE 143.

■ PAUL RAHILLY

Paul Rahilly's oil paintings are visual explorations in which the medium conveys the message. Although there is a strong image present, the paintings are as much about paint as they are about image. Each area of the painting is treated as a painting in itself, with its own space, color and surface independent of the object represented. ■ PAGE 112.

■ KEITH & VALERIE RAIVO

Piles of domestic hardwoods fill Keith and Valerie Raivo's shop. Oak, elm, walnut, ash and cherry are cut into thin planks and sorted; only wood with straight grain and no defects finds its way into their baskets. Their work is held together with square-shanked, copper nails, with the end results as functional as they are durable. ■ PAGE 76.

■ MELODEE MARTIN RAMIREZ

In the creation of her narrative oil paintings, Melodee Martin Ramirez follows a very traditional process. The first layer over the gesso ground is the imprimatura. Grisaille techniques establish the preliminary drawing and modeling of the finished subject. Glazing and then alla prima painting finish the piece. Collections include: U.S. Vice Presidential Residence, Washington, DC. ■ PAGE 124.

■ BOB RASHID

Bob Rashid's roots are in journalism, so his camera technique is to respond to what he sees and feels. Landscapes are his passion, and through his work he strives to reflect the beauty we all share with nature. Collections include: Wisconsin Arts Board, WI; Miller Art Museum, Sturgeon Bay, WI. ■ PAGE 205.

■ CHRISTOPHER RIES

Christopher Ries does not blow or laminate glass like most glass artists. Instead, he works in the traditional reductive sculptural mode — he begins with a block of solid optical glass and then reduces it to the desired form. His work ranges from small sculptures measuring only a few inches high to life-size creations. ■ PAGE 42.

■ HOLLY ROBERTS

Holly Roberts uses her own photographs as a ground for heavily painted, etched, scraped and smeared images. After paint is applied to the photograph, the original image often becomes indiscernible, though its subject matter, form or composition guides her through the finishing process. Collections include: Art Institute of Chicago, IL; Museum of Photographic Art, San Diego, CA. ■ PAGE 132.

JAMIE ROBERTSON
Jamie Robertson prides himself on impeccable craftsmanship. Each of his pieces redefines the distinction between craft and art, between the exclusive domains of function and aesthetics. ■ PAGE 70.

RED ROHALL
Taking photographs with a cheap disposable camera so as not to draw attention to himself, Red Rohall collects images of unique and unusual roadside architecture. He then paints these images directly onto the canvas, never creating a sketch or study, building the surface with hundreds of layers of paint. Collections include: United States Embassy, Stockholm, Sweden. ■ PAGE 121.

ROSETTA
Working directly in clay without preliminary drawings, Rosetta defines the grace and flow she sees in animal form and movement using a minimum of carefully selected shapes. She captures the essential spirit of her animal subjects in a hard-edged yet fluid style. Collections include: Lincoln Park Zoo, Chicago, IL; MGM Grand Hotel, Las Vegas, NV; Hewlett-Packard Company, Loveland, CO. ■ PAGE 146.

KATHERINE STEICHEN ROSING
Scratches on the surface of Katherine Steichen Rosing's work often suggest rain, sleet and other forms of precipitation. She paints with built-up layers of acrylic, using techniques such as scumbling and glazing to suggest a metaphor for the changes in nature that are her continual inspiration. ■ PAGE 109.

BIRD ROSS
Bird Ross begins a new work by determining the form and then deciding how to construct it and what materials to use. She engages in a continuous dialog with her materials — asking them to do things they probably weren't meant to do. Ultimately, fabric and form coincide, held together by carefully chosen thread, completed with her signature transformations. ■ PAGE 167.

GINNY RUFFNER
Ginny Ruffner's glass sculptures are made with the process of lampworking, in which glass rods and tubes are softened over a flame, and then bent to shape. Collections include: Metropolitan Museum of Art, New York, NY. ■ PAGE 176.

JOANNE RUSSO
JoAnne Russo begins with a black ash log, pounding it to separate the growth rings. She weaves her baskets over wood molds that have been cut into pieces and reconstructed with velcro; this allows her to remove the mold from the basket and use it again. Collections include: Museum of Fine Arts, Boston, MA; Peabody-Essex Museum, Salem, MA. ■ PAGE 79.

MITCH RYERSON
Mitch Ryerson's art consists of multilayered compositions of many materials, shapes and ideas. His ultimate aim is to engage us with color, proportion, movement, repetition, function and humor. Collections include: Museum of Fine Arts, Boston, MA; City of Cambridge, MA; ARC International, New York, NY; Workbench Corporation, New York, NY. ■ PAGE 74.

SUSAN SCULLEY
Susan Sculley works in both oil sticks and pastels to create works that have the feel of landscapes suffused with light. Her compositions of color and elusive form capture the peace and beauty one experiences when communing with nature. Collections include: Amoco Corporation; Dean-Witter. ■ PAGES 2, 137.

OSCAR SENN
Oscar Senn works with oils on canvas. He begins each piece with an underpainting, usually in a color that contrasts with the overall tone of the piece. He uses a thickened turpentine, which gives the paint the consistency of maple syrup. The motivation behind his paintings has always been place and time — single moments of drama and mystery frozen in ambiguous action. ■ PAGE 126.

V. SHAW
V. Shaw's totems are built with a combination of clay techniques. Some parts are slab-built, others are coiled, wheel thrown or extruded. The clay surfaces are combed, airbrushed, dipped in glaze and high-fired. The forms are then stacked to create the totem. ■ PAGE 22.

STEVEN SHORES
Steven Shores incorporates all types of mixed media into his paintings — everything from lace to gold leaf can be found buried in his work, with each element carefully chosen for the theme it conveys. In his *State Fair* series, he explores a person's reflections on a day at the fair and how they provide the backdrop for emblematic objects that stand out as modern icons in a world still deeply rooted in the past. ■ PAGE 142.

JOSEPH SHULDINER
Joseph Shuldiner has always been fascinated by the primal essence of shelter. He uses both vernacular and indigenous architecture as well as locally accessible materials to construct functional objects that are also a vehicle for artistic expression. It is important for him to gather the material for each lamp in its native habitat: willow from local canyons and eucalyptus from neighboring hills. ■ PAGE 195.

■ JOSH SIMPSON

Josh Simpson is a self-taught glass artist whose works are included in many public and private collections. He is both a pilot and a deep-sea diver, and much of his imagery revolves around views of landscapes, real and imagined. Collections include: Smithsonian Institution, Washington, DC; Corning Museum of Glass, Corning, NY. ■ PAGE 179.

■ JERRY SKIBELL

Jerry Skibell's abstract work is minimally planned before he "attacks" the surface. Acrylics, spray paint, stencils and oils may all be incorporated into one painting or used singly on each canvas. His main objective is to be innovative, experimental and open to his own inspiration. Collections include: Academic Management Services, Inc., Boston, MA; Locke, Leddell & Sapp, Dallas, TX. ■ PAGE 131.

■ ELAINE SMALL

Elaine Small has displayed her watercolor and acrylic paintings in numerous shows and won several awards. Recently, however, her interest has turned toward fiber art, especially knotted linen baskets and sculpture. Many of these pieces have been exhibited internationally. ■ PAGE 110.

■ JAUNE QUICK-TO-SEE SMITH

The prints, drawings, mixed-media collages and paintings of Jaune Quick-to-See Smith often focus on the cultural status of Native Americans. She is well known as a spokesperson and historian for Native American artists, and a champion of environmental preservation. Collections include: Museum of Modern Art; National Museum of Women in the Arts, Washington, DC. ■ PAGE 119.

■ KENNETH STANDHARDT

Kenneth Standhardt's work is greatly inspired by a particular style of primitive vessel-making that involved pressing a layer of clay onto the interior surface of a basket. He strives to re-create these geometric patterns and convey the same strength of form, pattern and texture in his work. Collections include: Renwick Gallery, Smithsonian Institution, Washington, DC. ■ PAGE 78.

■ LYLE STARR

Lyle Starr appropriates silhouettes of media images to create flowing, mercurial and complex interwoven compositions. ■ PAGE 50.

■ SUSANNE G. STEPHENSON

Susanne G. Stephenson works with wheel-thrown elements, coils, flat slabs and extruded shapes. She then applies thick, wet, colored slip and vitreous engobes to the clay surface with her hands, following up with sponges, homemade brushes and brooms. Collections include: American Craft Museum, New York, NY; Los Angeles County Museum of Art, CA. ■ PAGE 163.

■ ARTHUR STERN

Arthur Stern comes out of an American glass tradition, drawing inspiration from Frank Lloyd Wright and the Prairie School. Also a student of the work of German post-war glass designers like Johannes Schreiter, Ludwig Schaffrath and Jochem Poensgen, he has combined these influences into a design sensibility strongly inspired by architecture. ■ PAGE 106.

■ BILLIE RUTH SUDDUTH

In her baskets, Billie Ruth Sudduth uses the same mathematical ratio contained in the spacing of spirals on a seashell and florets in the center of a daisy — the Golden Mean — used to unify design since ancient Greece. Collections include: Renwick Gallery, Smithsonian Institution, Washington, DC; American Craft Museum, New York, NY; Mint Museum of Craft + Design, Charlotte, NC. ■ PAGE 92.

■ JOHN EDWARD SVENSON

John Edward Svenson's interior and exterior sculptures have been created in bronze, steel, cast stone and wood. He is considered a master of medallic and relief sculpture, and his architectural, commemorative, historical and residential commissions span more than 40 years. ■ PAGE 158.

■ BYRON TEMPLE

Byron Temple began his career as an apprentice at the famed Leach Pottery in England, where each day he was given a "make list" — a schedule of what he was required to make that day. He still uses this organizational tactic as he creates vessels, bowls and covered forms of unusual beauty. Collections include: Cooper Hewitt Museum of Design, New York, NY; Newark Museum, NJ. ■ PAGE 81.

■ TERRY THOMMES

Terry Thommes' sculpture is bounded by myth and metaphor. Works that suggest the limits and constraints of the regulated figure in space are often arranged in groups or couples, while non-figurative works assume identities that offer interpretations of modern tools and devices. Collections include: Castello Di Gargonza, Monte San Savino, Italy; Shannon Foundation, Atlanta, GA. ■ PAGE 27.

■ DANE TILGHMAN

Dane Tilghman uses watercolors to their full capacity, often applying pure pigment in order to develop rich tones. He terms his style "Tell Tale Art" and incorporates primitive elongation, realism and his own brand of surrealism in an effort to reveal stories from history as seen through the eyes of a child. ■ PAGE 125.

■ MICHAEL TORRE

Michael Torre's career has taken him from engineer and coal miner to potter, and now artist. He has lived in three countries and several states, and teaches art, finding in his students an ongoing source of inspiration. ■ PAGE 172.

■ JACK TWORKOV

Jack Tworkov was one of the abstract expressionists who, along with Willem de Kooning, founded the New York School of the 1940s and early 1950s. Throughout his career, his works evolved from figures, landscapes and still lifes to pieces that expressed order through the use of grids, geometries and systems. Collections include: National Gallery of Art, Washington, DC; Solomon R. Guggenheim Museum, New York, NY. ■ PAGE 109.

■ LEONARD A. URSO

Leonard A. Urso's large-scale copper sculptures are abstractions of human forms. He hand forms and raises 8-gauge copper and embellishes the surface with a variety of patinas. He heads the metal department at the Rhode Island School of Design.
■ PAGE 66.

■ ROSS VAN DUSEN

Painting in layers that consist almost entirely of reds, yellows and blues, Ross Van Dusen uses an underpainting color complementary to the final finish. Since he uses a material that makes the layers transparent, colors dance and become rich in their stark primary exchange. ■ PAGE 13.

■ NICOLA VIGINI

Nicola Vigini, a native Roman, specializes in the classical techniques of trompe l'oeil, mural painting, wood graining and faux marble. He is an internationally recognized master in the field of decorative painting. Commissions include religious institutions, residences and large commercial spaces throughout the country. ■ PAGE 39.

■ LIZ VIGODA

Each of Liz Vigoda's stoneware vases is thrown on the potter's wheel and hand painted with ceramic stains and glazes in a contrasting pattern that creates spatial rhythms and tensions of balance. After bisque firing, it is fired again with a clear gloss glaze.
■ PAGE 103.

■ RIMAS VISGIRDA

Rimas VisGirda draws inspiration for his imagery anywhere from popular culture to historical ceramic design. His work has changed considerably in the 30 years that he has been creating pottery, evolving from simple, functional forms to the sophisticated, whimsical pieces he now produces. Collections include: Arkansas Art Center, Little Rock; Belgium State Museum, Brussels. ■ PAGE 82.

■ MAUREEN WARREN

Commonly working with oil on canvas, Maureen Warren presents ideas that have triggered her imagination for the past two decades. The work usually does not include human figures, though viewers of her detailed imagery often sense a human presence. Collections include: Ecology Museum Permanent Collection, E.G.G. Gallery, Chicago, IL. ■ PAGE 159.

■ MARVIN WAX

Marvin Wax considers himself a photographer of light, with the world as his subject. His ultimate hope is that the content of his photographs will speak and illuminate his personal artistic voice, and that hard work and thought will lead to progress and growth. ■ PAGE 193.

■ CAROL WEBB

Carol Webb begins her works with thin sheets of copper and silver that she joins with heat. Next, the pattern is ironed to the copper from an acetate photocopy. After a ferric chloride bath, the newly etched metal is soaked and scrubbed. Only after this extensive process can the metal be cut and bent to form various shapes. ■ PAGE 104.

■ AMANDA WEIL

Amanda Weil brings 15 years of experience as a fine art photographer to the craft of furniture design. Her luminous tables, lights and screens integrate her meditative studies of nature with the familiarity of the home. By combining photography with translucent materials, she incorporates visions of nature into a range of furniture, offering collectors a locus of tranquility in everyday life. ■ PAGE 139.

■ DICK WEISS

Dick Weiss' technique is both classic and straightforward: design, cut, lead, putty, clean. His love for stained glass windows, blown glass vessels and paintings has defined his career and helps shape his delicate screens into small, moving walls of light. Collections include: Victoria and Albert Museum, London, UK; City of Seattle, WA; Corning Museum of Glass, NY.
■ PAGE 170.

■ MARY BOONE WELLINGTON

Known for an economy of form, rich surfaces and colorful patinas, Mary Boone Wellington's work conveys powerful universal images with a lightness of spirit. Collections include: City of Flagstaff, AZ; Gillette; The Discovery Channel; Jockey; Anthropologie. ■ PAGE 197.

■ GILDA WESTERMANN

After shaping her porcelain forms on the wheel, Gilda Westermann bisque fires and coats them with a transparent glaze. From the smallest piece to the largest grouping, the fusion of touch and vision is her trademark. ■ PAGES 14, 188.

CANDONE M. WHARTON

Candone M. Wharton uses a slab roller and a few kitchen utensils to create textures on slabs and pinched bases. She then builds up her forms with layers of coils that are carved or textured with basket weave and block print designs. Her raku finish is inspired by the lusters of Moroccan pottery. Collections include: Coca-Cola Corporation, Atlanta, GA. ■ PAGE 173.

STEPHEN WHITTLESEY

Stephen Whittlesey's creations in salvaged wood have grown out of the "making do with what you have" attitude he was raised with. It gives him great pleasure to find a craggy piece of century-old wood and find some way to rescue it and give it a new purpose. ■ PAGE 34.

ANNA WOLF

Many of Anna Wolf's books consist of multiple shapes folded and joined on edge. This construction gives each book an accordion-like flexibility that allows for display in a variety of angles and shapes. Collections include: Kunstgewerbe Museum, Frankfurt, Germany; Klingspor Museum, Offenbach, Germany; Graphische Sammlung Albertina, Vienna, Austria. ■ PAGE 105.

BRUCE WOLFE

Using old-fashioned water-based clay, Bruce Wolfe shapes the dull mass of his material with the supple curves and hard lines of the human figure, relying on models whenever possible to provide the exact angles of a three-dimensional form. ■ PAGE 67.

JEAN WOLFF

Jean Wolff loves water, and paints according to her affection, applying wet paint to a wet ground. As moisture builds and gravity weighs down on the canvas, the paint begins to disperse, moving across the surface in modulated sheets or waves of color. Collections include: Standard Federal Bank, Troy, MI; Werner Kramarsky, New York, NY. ■ PAGE 109.

RICK WRIGLEY

Rick Wrigley draws on his thorough understanding of the past to inspire his furniture. Influenced most recently by the Herter Brothers, Daniel Pabst and other designers of the late-19th century, he crafts his tables, chairs, mirrors and cabinets from exotic woods, inlays and veneers, respectful always of the place of historical design. ■ PAGE 83.

JIRO YONEZAWA

Jiro Yonezawa uses traditional Japanese bamboo basketry techniques in combination with American materials to reflect the traditions of Japan and the unrestrained style of the United States. Yonezawa considers his work an expression of detailed precision. In each basket there is the contrast of disciplined formality in technique and natural freedom in form. ■ PAGE 46.

ERMA MARTIN YOST

In her fiber pieces, Erma Martin Yost explores the significance of the hand as a powerful symbol of expression and communication. All of the imagery in her current series is drawn from the handprints and pictographs left on canyon walls by natives of the American Southwest. Collections include: American Craft Museum, New York, NY; World Trade Center, Port Authority, New York, NY. ■ PAGE 94.

PEGGY FLORA ZALUCHA

Peggy Flora Zalucha chose watercolor as her medium because it allows more expression and emotion in her representational work. As for her subject matter, there is nothing too ordinary or pedestrian — she celebrates the overlooked and the commonplace in her compositions. Collections include: Lakeview Museum of Art and Sciences, Peoria, IL; Paine Museum of Art, Oshkosh, WI. ■ PAGE 21.

HAMID ZAVAREEI

Hamid Zavareei combines modern and historic techniques in his imagery, often suggesting art's historical figures. He begins by texturing the canvas with mastic or paint and then applies heavy layers of oil. Translucent glazes — often mixed with varnishes used by 16th-century masters — finish the paintings. Collections include: Carnegie Art Museum, Oxnard, CA. ■ PAGE 199.

LARRY ZGODA

Larry Zgoda is recognized for his innovative coupling of new design vocabularies with traditional stained glass techniques, expanding the potential of glass as a contemporary architectural art. The refractive and reflective qualities of a wide scope of glass materials are imaginatively engaged to create luminescent works of art. Collections include: TCF Tower, Minneapolis, MN. ■ PAGE 108.